Surviving Disaster

Surviving Disaster

The Role of Social Networks

Edited by

Robin L. Ersing
University of South Florida, School of Social Work

Kathleen A. Kost
University at Buffalo, School of Social Work

LYCEUM
BOOKS, INC.

Chicago, Illinois

© Lyceum Books, Inc., 2012

Published by
LYCEUM BOOKS, INC.
5758 S. Blackstone Ave.
Chicago, Illinois 60637
773 + 643-1903 (Fax)
773 + 643-1902 (Phone)
lyceum@lyceumbooks.com
http://www.lyceumbooks.com

6 5 4 3 2 1 12 13 14 15

ISBN 978-1-933478-51-7

Printed in the United States of America

© Fotolotti | Dreamstime.com

Library of Congress Cataloging-in-Publication Data

Ersing, Robin L.
Surviving disaster : the role of social networks / Robin L. Ersing, Kathleen A. Kost.
 p. cm.
Includes bibliographical references and index.
ISBN 978-1-933478-51-7 (pbk. : alk. paper)
1. Disasters—Social aspects. 2. Community leadership. 3. Social networks. 4. Disaster relief. 5. Emergency management. I. Kost, Kathleen A. II. Title.
HV553.E77 2012
363.34′8—dc23

 2011022804

From Kate
To my children, Eric, Jordan, and Rose, who inspire me with their love and joy.

From Robin
To E., who has taught me to love, laugh, and let it be. Together we are strong.

Contents

List of Tables and Figures

Tables

Figures

Preface

Why this book? Why now? These were the questions we asked ourselves as we sought to gain some understanding of why, with the suffering and devastation of natural disaster so prevalent, did some communities, and some groups within communities, not only survive but also develop strategies that mitigate the effects of possible future disasters. In contrast, other communities, despite surviving, fail to bounce back and instead resign themselves to fate. Aside from the factors of location and size we sought to identify the social and contextual differences between these communities. In turn we wanted to know if the differences could be changed, could be influenced by community practitioners.

This investigation led us not only to examine the empirical literature but also to reflect on our own practice experiences. What we came back to time and again was the role social networks played in mitigation efforts. As social workers we found this perfectly reasonable: communities cannot exist without the relationships between its members. Effective solutions occur only through the cross-fertilization of community members who are committed to its coproduction.

It is our hope that the collection of ideas and applications assembled in this text will contribute to the effort of strengthening communities in their response to natural disasters.

Acknowledgments

No work of this scope can be accomplished alone. We wish therefore to express our sincere gratitude to Alicia Kohlhagen and Lacy Lewis for all their tireless assistance in the preparation of this manuscript—it is no easy task to ensure the accuracy of references as we keep adding them! We want to thank the outstanding staff at Lyceum for their amazing support throughout this process. We also extend a very special thank you to our publisher, David Follmer, for his patience, guidance, and persistence as we sought to pull the pieces of this text together into a coherent whole. We are also grateful to our reviewers, John Tropman, Lambert Maguire, and Stacey Borasky, for their insightful comments which contributed to the quality of this work. Finally, we extend our sincerest appreciation to the colleagues who contributed their work to this endeavor. We have enjoyed sharing this labor of love with you.

Approaching Practice

Social Networks in the Context of Disasters

Robin L. Ersing and Kathleen A. Kost

All disasters are local. Whether a tornado touches down and severely damages neighborhoods of a small midwestern town or an oil platform explodes in the Gulf of Mexico leaking millions of gallons of petroleum across several coastal states, disaster management begins at the local level (U.S. Department of Homeland Security, 2008). Local communities vary, however, in their ability to anticipate, coordinate, and implement disaster preparedness and response plans necessary to manage a hazardous event. Despite this, we believe communities have the potential to identify and harness the capacity of local social assets and resources that, when activated, hold the promise of promoting survival and sustaining recovery efforts. This may be particularly salient for natural disasters, where well planned preemptive interventions can buffer the impact of the hazard on the community and promote a more resilient recovery. Such preplanned interventions or mitigation strategies are intended primarily to not only reduce the physical destruction that often results from the forces of nature, or in some instances of humankind, but also alleviate the toll taken on personal, social, and economic conditions.

The purpose of this book is to offer practical advice to those involved in disaster preparedness and recovery work, with an emphasis on the utility of local assets, specifically social networks, for mitigating the

1

impact of a disastrous event on people and their communities. As knowledge in this area continues to emerge, we provide an entry point for understanding the role social networks can play in the field of disasters. It is hoped that those involved in community-based disaster preparedness and recovery work may decide to incorporate what is known about social networks into local response strategies.

Understanding Disaster

Disasters derive from the inability of a community to adequately manage the impact of a hazard. Whether local or global, man-made or natural, all disasters begin with a hazardous event (e.g., tornado, earthquake, oil spill, chemical contamination). However, not all hazards result in a disaster. A disaster always involves some type of destructive force that impacts a vulnerable population or susceptible location. A lack of sufficient resources necessary to withstand and overcome the impact of a hazard places a community in the position of seeking recovery assistance from outside sources in order to restore normal functioning. Communities that are well prepared and equipped in terms of available resources are often better able to withstand the severity of a hazard and hence less likely to declare a disaster (Wisner, Blaikie, Cannon, & Davis, 2004).

Phases of a Disaster

Disaster management is typically divided into four phases: mitigation, preparedness, response, and recovery. Mitigation involves the development of strategies to minimize the effects of a disaster and may include adopting new policies or practices such as enhanced building codes or methods for educating communities. Preparedness deals with response planning to ensure households, businesses, and communities are ready should a disaster strike. Response focuses on the immediate aftermath of a hazard and includes such functions as search and rescue and providing immediate relief for survivors such as water, food, shelter, and medical care. Recovery addresses longer-term needs related to helping a community return to a level of predisaster functioning.

Disaster Typology

Like the hazards that precede them, disasters vary in several important ways. Berren, Beigel, and Ghertner (1980, p. 104) were among the first

to develop a disaster typology outlining five dimensions of a disaster: type, duration, potential for occurrence, degree of personal impact, and control over future impact. Disasters are typically thought to emanate from either natural or man-made circumstances. On occasion, both types can be present. In 2005 the city of New Orleans and its surrounding communities experienced the landfall of a category 4 hurricane, followed by a breach of the levee system, which was unable to withstand the resulting storm surge. Both nature and the Army Corps of Engineers were found accountable for contributing to the dislocation of nearly one million people and the deaths of over eighteen hundred others in the aftermath of Hurricane Katrina (U.S. House of Representatives, 2006).

The duration of a disaster can range from mere seconds to much longer periods. People living along the Mississippi and Missouri Rivers endured several months of intense flooding in what has been called the Great Flood of 1993. Residents living in the path of the flood experienced more than one hundred days of overflowing riverbanks and significant flooding throughout adjacent communities. Estimates of the toll from the flood include the loss of over thirty lives, the destruction of more than one hundred thousand homes, and over \$12 billion in property and agricultural damage (Galloway, 1995; Sherraden & Fox, 1997). In contrast, tremors from the 1906 San Francisco earthquake took less than sixty seconds to level buildings and ignite fires fueled by ruptured gas lines that together claimed several thousand victims and left over two hundred and fifty thousand people homeless (Winchester, 2005).

The potential for a disaster to occur is another factor in the typology. Often geography and meteorology combine to increase the probability that a natural disaster will strike. Communities located within the central plains of the United States, specifically between the Rocky and Appalachian Mountains, tend to realize an increased likelihood of exposure to tornadoes. Although a tornado can make impact on land in nearly any location, Texas, Oklahoma, and Kansas are the top three states in the United States in terms of experiencing tornadoes (National Climatic Data Center, 2007). Unlike natural disasters, man-made disasters are often more difficult to predict. Mass casualty events resulting from human error, such as an airplane crash or oil tanker spill, tend to be isolated occurrences, and such disasters have a lower probability of recurrence.

The degree of personal impact from a disaster varies according to levels of vulnerability and resilience. Social vulnerability refers to an individual's capacity to prepare for and recover from the impact of a hazard (Blaikie, Cannon, Davis, & Wisner, 1994). Several factors believed to influence a person's level of vulnerability are income, age, physical

ability, and social support. Individuals who are poor, elderly, disabled, and/or lack social ties or networks are slower to recover from a disaster and may not return to a level of predisaster functioning for a long time after the event (Buckle, 2006). The personal impact from a ten-day heat wave that struck New York City in 1896 supports the theory that socially vulnerable populations are likely to be among the victims of a disaster. As temperatures rose above ninety degrees each day during the heat wave, those residing in tenement housing faced indoor temperatures as high as one hundred twenty degrees. In all, over thirteen hundred people died, with poor, immigrant laborers among the hardest hit (Kohn, 2010). According to Kohn, the loss of life might have been greater if not for the decision made by Theodore Roosevelt, then head of the Board of Police Commissioners, to distribute ice to the city's poor. Nearly a century later, the city of Chicago faced a similar disaster with a heat wave lasting five days and claiming the lives of seven hundred fifty people (Klinenberg, 2002). Klinenberg points to the elderly poor as constituting the greatest portion of heat-wave victims. The deaths have been attributed to a lack of air-conditioning in homes, shut windows because of a fear of crime, and, in the case of older males, having fewer social supports.

Finally, according to Berren et al. (1980), "there are some disasters that man has the opportunity to prevent from occurring again or at least to reduce their potential devastating consequences" (p. 107). Control over the future impact of a disaster is often determined by the nature of the hazard and viable mitigation strategies. Unlike a natural disaster, man-made disasters present a greater opportunity for controlling future impact. In the 1970s, families residing in an area known as Love Canal, in Niagara Falls, New York, became concerned about the growing number of people experiencing severe health problems. A survey by the homeowners' association revealed that over half the children born between 1974 and 1978 had been diagnosed with a birth defect (Blum, 2008). Lois Gibbs, a local resident turned activist, advocated on behalf of her Love Canal neighbors. She waged a battle for several years calling on the government to intervene and address the health concerns that were linked to the dumping of industrial chemicals by the Hooker Chemical Company in the 1940s and 1950s. After burying drums of chemical waste, Hooker Chemical had sold the land to the local school board, and a low-income community was eventually developed on the site. After a lengthy fight, the families of Love Canal were eventually relocated and the homes and school barricaded by a fence erected to keep people out of the hazardous area. To ensure that the disaster would not cause future harm, the government required, under the Superfund Act, the chemical company to conduct a full-scale cleanup of the site, at an estimated cost of nearly $130 million. The Superfund

Act, adopted by Congress in 1980, was intended to mitigate the threat of environmental disasters such as Love Canal from occurring in other communities.

This book addresses primarily the relationship between social networks and natural disasters, rather than the broader scope of both natural and man-made hazards. The reason for this stems from several factors in the above typology (Berren et al., 1980). First, although a natural hazard such as a tornado, earthquake, hurricane, or tsunami cannot be prevented, these events can be monitored using forecasting technology to predict such elements as the location, strength, duration, and in some instances the estimated time of impact. Such forewarning provides an opportunity to educate communities about the importance of preparedness. Furthermore, understanding the characteristics of a community in terms of vulnerable populations and the susceptibility of geographic locations can aid in the development of mitigation strategies that may promote resilience in recovery. For example, knowing that the Gulf Coast area of Florida is prone to hurricanes between June and November each year is important. However, when this information is coupled with data that reveal the existence of a significant number of mobile home communities concentrated along that susceptible coastline, the ramifications for loss of life and property become more urgent. An important mitigation effort in this case has been the enactment of a mandatory evacuation policy for residents living in manufactured homes. Consequently, knowledge of and access to local assets, including social networks, may be a lifeline for some households.

Understanding Social Networks

Social capital can be thought of as the glue that holds together the fabric of our lives. It would thus seem that understanding how that social glue might be incorporated into mitigation and preparedness strategies to buffer the impact of a natural hazard is worthy of consideration.

Missing from much of the disaster management literature has been the important role social capital, and more specifically social networks, play in disaster mitigation and preparedness. Recently, attention has been given to understanding the potential these concepts have for building community disaster resilience (Magsino, 2009). Although definitions of social capital vary, our interest is in Putnam's (1995) characterization, which references "features of social organization such as networks, norms, and social trust that facilitate coordination and cooperation for mutual benefit" (p. 67). Nahapiet and Ghoshal (1998) further affirm that resources and assets accumulated through the building of

social capital are embedded and mobilized through the development of networks and relationships.

Often social capital is discussed in terms of the processes of bonding and bridging. At a microlevel, bonding social capital is concerned with the specific networks and relationships to which individuals belong. Bonding allows the exchange of information and resources between people in order to achieve shared goals (Nahapiet & Ghoshal, 1998). Bridging social capital by comparison occurs at a macrolevel and is used to connect diverse groups beyond the more tight-knit and homogeneous relationships that are often forged through bonding (Putnam, 2000). Bridging provides an opportunity to broaden the scope and variety of resources that can be accessed. Studies from Hurricane Katrina (Fussell, 2006; Hawkins & Maurer, 2010) suggest survivors representing vulnerable populations used both bonding and bridging social capital as part of their evacuation and recovery efforts. For example, close ties forged through established individual networks (bonding) provided some low-income individuals with access to shared resources for shelter and food, thus enabling their successful evacuation. Similarly, longer-term recovery and redevelopment needs have been supported through connections across communities (bridging) to maximize assets and capital, including access to schools so parents and children could reestablish some semblance of routine.

Indeed, social networks reflect the connections and relationships between individuals ranging from very close bonds with family or kin to more casual friendships or interactions with others through groups and organizations. Often people establish networks through ties to church, recreational activities, volunteer efforts, work, or any variety of other social outlets. Family, friends, and neighbors are among the most common network links. An important product from the development of social networks is the mutual exchange of resources and assets. In other words, social networks not only serve to build forms of collective support but also to connect individuals with valued resources.

The role of social networks in disaster resilience models, particularly in the areas of hazard mitigation and preparedness planning, continues to emerge (Buckle, 2006; Dynes, 2002). Several major hurricanes impacting the United States during the past decade have led researchers to focus attention on the utility of informal social ties in prompting individuals and families to seek safety by leaving home (Dash & Gladwin, 2007; Haines, Beggs, & Hurlbert, 2002; Whitehead et al., 2000). Indeed, the devastating impact of Hurricane Katrina on the city of New Orleans and the surrounding Gulf Coast in 2005 underscored the need for advanced knowledge of the way social networks function. Some have suggested this has importance for vulnerable populations that are socially and economically marginalized (Cutter, Boruff, & Shirley, 2003;

Moore et al., 2004; Real, 2007). Those who had linkages at the organizational level to networks of support and resources were more likely to escape the devastation successfully compared with those who were socially isolated (Zakour, 2008). Social networks thus merit additional study to help disaster managers and other responders understand how systems of informal social support may facilitate or hinder the decision-making process to prepare for and recover from a major storm.

In connection with the growing empirical literature on the function of social networks in disaster preparedness and recovery behavior, some recent observations are informative. According to Dynes (2002), "social networks provide the channels whereby individuals develop a perception of risk and can be motivated to take some type of preventative action" (p. 18). Social ties may also influence decision-making behavior when collective actions result in a set of norms for the group that could run counter to hazard-mitigation information (Dynes, 2002; Mileti, 1999). Such is the case when individuals choose to stay in their homes despite evacuation warnings and orders from emergency management officials. While social networks are thought to play a pivotal role in disaster evacuation decision making, it remains uncertain just how the collection of informal ties and relationships is used to arrive at an ultimate decision to leave or shelter in place.

The Power of Diversity in Social Networks

Some time ago Granovetter (1973) established that even weak social networks and connections can serve as a link to a wider and more diverse range of resources. His work challenged the notion that outlets for supportive resources are found exclusively amid tight-knit circles of family, friends, and neighbors. This has led researchers to consider both the strength and the density of social networks. In some cases having strong ties with individuals who share similar social and economic characteristics has been shown to provide increased sources of support and improved outcomes for mental and physical health among disaster survivors (Haines et al., 2002; Haines & Hurlbert, 1992). In comparison, social connections deemed to be weaker in nature but providing greater network diversity suggest increased access to harder to obtain resources (Granovetter, 1973; Unger & Powell, 1980). Hurlbert, Beggs, and Haines (2006) coined the term *optimal networks* to represent a blending of these two perspectives. They suggest that individuals with access to social networks made up of relationships having strong ties with similar others (high density) and weaker social connections among a broader range of people (low density) are better able to access both supportive and more concrete resources to aid in disaster recovery.

The Power of Bridging Social Networks

The reality that all disasters are local events places neighborhoods and communities at ground zero for preparation and response activities. Whereas the glue of bonding social capital that strengthens trust between individuals is instrumental in mobilizing community assets to assist in mitigating the impact of a hazard, the influence of bridging social capital cannot be minimized. Connections between families, friends, and public institutions is essential to the success of disaster mitigation efforts. Such is the case when a lack of synergy in the goals and objectives between public and private sectors results in institutional deficits that inhibit cooperation and collective resolution of problems (Warren, Thompson, & Saegert, 2001). For example, a neighborhood that is either culturally or economically different from the larger community may lack sufficient connection to public institutions. These differences can be exacerbated by geographic isolation caused by, for example, an intervening highway or river. Instead of developing communication and resource links to public institutions, residents create and in turn invest in private organizations to meet their needs. Over time, the resources provided by these private organizations replaces those of public institutions. This in turn can inhibit knowledge, trust, communication, and connection between neighborhood residents and public institutions (Putnam & Feldstein, 2003).

Thus, relationships that bridge social networks within a community may influence its ability to adequately provide health services and public safety to members in the wake of a disaster (Sampson, 2001). Residents who trust that the decision-making process of public institutions is responsive to their needs are more likely to invest in their community than those who feel disenfranchised. Involving local, indigenous leaders of diverse networks may facilitate improved communication and distribution of needed resources between disaster responders and impacted communities, thus increasing the success of mitigation efforts. In other words, this may lead communities to harness both the bonding and bridging aspects of social capital to activate the necessary exchange of information and resources within and across diverse social networks.

Disaster preparedness can be thought of as an organizing principle embedded in the policies and service delivery systems of a community (i.e., in its fire, safety, and human service planning). Arguably this perspective supports the idea of strengthening social networks between individuals, families, organizations, neighborhoods, and communities. To supplement successful mitigation approaches, disaster prevention efforts should, as Putman and Feldstein argue (2003), "emphasize the centrality of relationships and interpersonal connection" (p. 269).

Social Networks and Disaster Management

Vulnerability to a disaster is often associated with the social context of the individual (Blaikie, Cannon, Davis, & Wisner, 1994). As mentioned, age, income, physical ability, and ties to social supports are several of the more prominent characteristics believed to hinder disaster preparation and evacuation from an impending hazard. The collective actions of a community, however, are thought to have the potential to reduce social vulnerability and increase chances of survival even though the hazards associated with a disaster remain (Wisner et al., 2004). The concept of relational organizing has potential as a disaster management tool for engaging vulnerable residents of resource-limited communities to improve the likelihood of obtaining preparedness information and support through informal mechanisms. This form of community organizing relies on one-on-one contact with individuals who represent different social networks (Briggs, 2008). Local leaders, such as the clergy and others, who represent indigenous neighborhood groups bring together the diverse interests of the community in order to share concern around a common issue. Such an approach may be beneficial for engaging vulnerable populations in the process of disaster planning (Rubin & Rubin, 2001).

Likewise, evidence suggests that communities that promote the inclusion of disaster risk management activities among diverse neighborhood groups may be more successful in protecting vulnerable citizens than those localities that use solely a bureaucratic, top-down approach (Pine, 2009). During an economic downturn, for example, municipalities coping with a loss of revenue may be forced to slash budgets for public health and safety services. As a result, vulnerable communities may be further hindered in their ability to effectively cope with a natural disaster. To counter this, hazard managers across the country are beginning to adopt a "community as resource" model to plan for and respond to disasters (Lichterman, 2000, p. 265). Building on the accumulation of social capital within the community, programs such as the Community Emergency Response Team operate through the development of social networks that bridge organizations (e.g., fire departments, emergency management) and citizen groups, resulting in cost-effective disaster preparedness and response strategies at the grassroots level.

The Role of Social Networks

The chapters that follow address the important role of social networks in dealing with disasters through collaboration at the multisystem and

multiagency levels. In chapter 2, Mukherjee and Soliman describe a social network model for developing strategies toward natural-disaster mitigation and preparedness. The model takes a relational approach (Wasserman & Faust, 1994) to underline the importance of the social interactions that exist across individuals, families, organizations, neighborhoods, and communities and calls for identifying and using the benefits emerging out of such interactions for disaster management and mitigation.

In chapter 3 Kost and Edwards apply the concepts of social networks and community development to the readiness of a community to collectively identify and coproduce solutions that can mitigate the effects of a disaster. They argue that by incorporating the methods of the Community Readiness Model in disaster planning communities are able to accurately assess, use, and sustain strong social networks. A community's ability to respond effectively to a disaster, regardless of whether it is natural, environmental, or social, is dependent upon the linkages leaders have created and sustained across a variety of systems. They describe these links and the forms they may take, such as money, evacuation vehicles, and shelters, as well as human resources such as experience in planning and organization. The chapter includes suggestions for identifying gaps in community resources, which may be in the form of opportunities presented by local zoning regulations and statutes that foster cross-system collaboration.

In chapter 4 Markus discusses the application of the Community Readiness Model to the Wright, Wyoming, Tornado Recovery Project. This project, funded by the Federal Emergency Management Agency and the Substance Abuse and Mental Health Services Administration, assisted the residents of Campbell County in their recovery from a devastating tornado. A unique aspect of this chapter is a description of the application of social networks in the crisis recovery project and the theory and literature that guided this process under the auspices of the federal government. In particular it identifies and discusses the role of social workers and other professionals in this project and provides evidence of the outcome of the initiative, with strategies for sustaining the social networks for future applications.

The effects of family and neighbor relationships and economic and cultural resources on various aspects of hurricane preparedness for a particularly vulnerable population are investigated in chapter 5. Kusenbach and Taylor note that the region's hazard risk is among the highest on the Gulf of Mexico, considerably higher than that of New Orleans, the city devastated by Hurricane Katrina and subsequent flooding in 2005. Mobile home residents are a particularly vulnerable population due to the high susceptibility of their homes to wind and, in coastal areas, flood damage. The complex positive and negative impact of kin,

neighbor, and institutional networks on stockpiling supplies and planning for evacuation are presented. An interesting aspect of this research is the significance of pets, which are consistently viewed as family members, in shaping mobile home residents' preparedness activities. The chapter concludes with a brief discussion of practical insights and recommendations regarding social and other forms of capital that will increase the resiliency of a particularly vulnerable and, to date, understudied population.

In chapter 6 Mathbor and Kost discuss the role of leadership and management in disaster planning and mitigation efforts in East Asian and Pacific communities during the 2007 tsunami. They examine the scope and prospects for effective use of invisible assets of a community such as social networks, social cohesion, solidarity, and social interaction in disaster preparedness and mitigating the consequences of natural disasters that impact coastal regions. The chapter extends the discussion of social networks to the formulation of policy directives that emphasize the emergence of indigenous leaders in community collaboration and coordination with marginalized and resource-poor communities. It concludes that processes by which communities use social networks as a vehicle for effective service delivery before, during, and after a disaster must not only be comprehensive but inclusive as well.

Finally, in chapter 7 Ersing presents a community outreach and education strategy called CODE ONE that was designed to promote adaptive capacity and disaster resilience at the neighborhood level. Through the use of social networks, community members are able to assess local vulnerabilities and assets and use this information to create a seventy-two-hour readiness and response plan specific to the neighborhood environment. Networking with emergency service personnel offers neighborhood residents an additional opportunity to access resources and training to further promote the ability to bounce back in the aftermath of a disaster.

As we stated, the purpose of this book is to offer practical advice to those involved in disaster preparedness and recovery work, with an emphasis on the role of local assets, specifically social networks, in mitigating the impact of a disastrous event on people and their communities. Therefore, our overarching aim is to present both theoretical models and evidence-based applications that incorporate social networks in the realm of disaster management work to promote community resilience. Each of the following chapters presents a different perspective on understanding the importance of social networks in the context of primarily natural disasters. Four core areas thread through the chapters: hazard mitigation, geographic environment, social vulnerability, and community participation.

References

Berren, M. R., Beigel, A., & Ghertner, S. (1980). A typology for the classification of disasters. *Community Mental Health Journal, 16*(2), 103–111.

Blaikie, P., Cannon, T., Davis, I., & Wisner, B. (1994). *At risk: Natural hazards, people's vulnerability, and disasters.* London: Routledge.

Blum, E. D. (2008). *Love Canal revisited.* Lawrence, KS: University Press of Kansas.

Briggs, X. S. (2008). Community building: New (and old) lessons about the politics of problem-solving in America's cities. In J. DeFilippis & S. Saegert (Eds.), *The community development reader* (pp. 36–40). New York: Routledge.

Buckle, P. (2006). Assessing social resilience. In D. Paton & D. Johnston (Eds.), *Disaster resilience: An integrated approach* (pp. 88–104). Springfield, IL: Charles C Thomas.

Cutter, S. L., Boruff, B. J., & Shirley, W. L. (2003). Social vulnerability to environmental hazards. *Social Sciences Quarterly, 84*, 242–261.

Dash, N., & Gladwin, H. (2007). Evacuation decision making and behavioral responses: Individual and household. *Natural Hazards Review, 8*(3), 69–77.

Dynes, R. (2002). The importance of social capital in disaster response. Preliminary Paper #327. University of Delaware Disaster Research Center.

Fussell, E. (2006). Leaving New Orleans: Social stratification, networks, and hurricane evacuation. *Understanding Katrina: Perspectives from the social sciences.* Retrieved March 5, 2011, from http://understandingkatrina.ssrc.org/Fussell/.

Galloway, G. E. (1995). *Learning from the Mississippi flood of 1993: Impacts, management issues, and areas for research.* Paper presented at the U.S.-Italy Research Workshop on the Hydrometeorology, Impacts, and Management of Extreme Floods, November 1995, Perugia, Italy.

Granovetter, M. S. (1973). The strength of weak ties. *American Journal of Sociology, 78*(6), 1360–1380.

Haines, V., Beggs, J. J., & Hurlbert, J. S. (2002). Exploring structural contexts of the support process: Social networks, social statuses, social support, and psychological distress. *Advances in Medical Sociology, 8*, 271–294.

Haines, V., & J. S. Hurlbert (1992). Network range and health. *Journal of Health and Social Behavior, 33*, 254–266.

Hawkins, R. L., & Maurer, K. (2010). Bonding, bridging and linking: How social capital operated in New Orleans following Hurricane Katrina. *British Journal of Social Work, 40*(6), 1777–1793.

Hurlbert, J. S., Beggs, J. J., & Haines, V. A. (2006). Bridges over troubled waters: What are the optimal networks for Katrina's victims? *Understanding Katrina: Perspectives from the social sciences.* Retrieved January 23, 2009, from http://understandingkatrina.sscr.org/.

Klinenberg, E. (2002). *Heat wave: A social autopsy of disaster in Chicago.* Chicago: Chicago University Press.

Kohn, E. P. (2010). *Hot time in the old town: The great heat wave of 1896 and the making of Theodore Roosevelt.* New York: Basic Books.

Lichterman, J. D. (2000). A community as resource strategy for disaster response. *Public Health Reports, 115*, 262–265.

Magsino, S. L. (2009). Applications of social network analysis for building community disaster resilience: Workshop summary. *National Research Council.* Retrieved March 5, 2011, from http://www.nap.edu/catalog/12706.html.

Mileti, D. S. (1999). *Disasters by design: A reassessment of natural hazards in the United States.* Washington, DC: John Henry Press.

Moore, S., Daniel, M., Linnan, L., Campbell, M., Benedict, S., & Meier, A. (2004). After Hurricane Floyd passed: Investigating the social determinants of disaster preparedness and recovery. *Family Community Health, 27*(3), 204–217.

Nahapiet, J., & Ghoshal, S. (1998). Social capital, intellectual capital, and the organizational advantage. *Academy of Management Review, 23,* 242–266.

National Climatic Data Center. (2007). *Tornado climatology.* Retrieved March 5, 2011, from http://lwf.ncdc.noaa.gov/oa/climate/severeweather/tornadoes .html.

Paton, D., & Johnston, D. (2006). *Disaster resilience: An integrated approach.* Springfield, IL: Charles C Thomas.

Pine, J. C. (2009). *Natural hazards analysis: Reducing the impact of disasters.* New York: Taylor & Francis.

Putnam, R. D. (1995). Bowling alone: America's declining social capital. *Journal of Democracy, 6,* 65 78.

Putnam, R. D. (2000). *Bowling alone: The collapse and revival of American community.* New York: Simon & Schuster.

Putnam, R. D., & Feldstein, L. M. (2003). *Better together: Restoring the American community.* New York: Simon & Schuster.

Real, B. (2007). Hard decisions in the Big Easy: Social capital and evacuation of the New Orleans area Hispanic community during Hurricane Katrina. In K. Warner (Ed.), *Perspectives on social vulnerability* (pp. 72–83). Bonn, Germany: United Nations University, Institute for Environment and Human Security.

Rubin, H. J., & Rubin, I. S. (2001). *Community organizing and development.* Boston: Allyn & Bacon.

Sampson, R. J. (2001). Crime and public safety: Insights from community-level perspectives on social capital. In S. Saegert, J. P. Thompson, & M. R. Warren (Eds.), *Social capital and poor communities* (pp. 89–114). New York: Russell Sage Foundation.

Sherraden, M., & Fox, E. (1997). The great flood of 1993: Response and recovery in five communities. *Journal of Community Practice, 4*(3), 23–45.

Unger, D. G., & Powell, D. R. (1980). Supporting families under stress: The role of social networks. *Family Relations, 29*(4), 566–571.

U.S. Department of Homeland Security. (2008). *National response framework.* (FEMA Publication No. P-682). Washington, DC: Author.

U.S. House of Representatives. (2006). *A failure of initiative: Final report of the Select Bipartisan Committee to investigate the preparation for and response to Hurricane Katrina.* Washington, DC: Author.

Warren, M. R., Thompson, J. P., & Saegert, S. (2001). The role of social capital in combating poverty. In S. Saegert, J. P. Thompson, & M. R. Warren (Eds.), *Social capital and poor communities* (pp. 1–28). New York: Russell Sage Foundation.

Wasserman, S., & Faust, K. (1994). *Social network analysis: Methods and applications.* New York: Cambridge University Press.

Whitehead, J. C., Edwards, B., van Willigen, M., Maiolo, J. R., Wilson, K., & Smith, K. T. (2000). Heading for higher ground: Factors affecting real and hypothetical hurricane evacuation behavior. *Environmental Hazards, 2,* 133–142.

Winchester, S. (2005). *A crack in the edge of the world: America and the great California earthquake of 1906.* New York: HarperCollins Publishers.

Wisner, B., Blaikie, P., Cannon, T., & Davis, I. (2004). *At risk: Natural hazards, people's vulnerability and disasters.* (2nd ed.). New York: Routledge.

Zakour, M. (2008). Social capital and increased organizational capacity for evacuation in natural disasters. *Social Development Issues, 30*(1), 13–28.

A Social Network Approach to Disaster Planning

Implications for Mitigation and Response

Dhrubodhi Mukherjee and Hussein H. Soliman

Natural disasters pose imminent threats to personal and community networks. Disasters not only deplete physical and human resources but also "socially distribute" vulnerabilities across communities, inflicting long-term psychosocial and mental health challenges to surviving social units (Ablah et al., 2010; Browning, Feinberg, Wallace, & Cagney, 2006). Preparedness and mitigation efforts for disasters have underscored the importance of involving communities in planning mechanisms, as evident recently in Haiti (Millard, 2010). This chapter presents a conceptual model that can be used to guide this effort. Identifying existing social ties, the authors argue that community members and community-based organizations can be a resource in disaster response efforts. Using examples from Hurricane Katrina, which ravaged the Gulf Coast of the United States in 2005, and the 2010 earthquake in Haiti, it explores the role of social ties and social support in disaster relief.

Community-based disaster preparedness (CBDP) is an approach that incorporates local knowledge and indigenous experiences into disaster mitigation planning (Adams, 2008; Benson, Twigg, & Myers, 2001). Moreover, limited resources and frequent lapses in government response to disaster relief efforts have shifted the bulk of responsibility of disaster management to civil society and nongovernmental organizations almost everywhere in the world (Daughtery & Blome, 2009;

Rocha & Christoplos, 2001; Tobin & Whiteford, 2002). National and international collaboration has been more frequent in recent times (examples include the earthquakes in Pakistan and Iran and the tsunami in the Asia-Pacific region) for sharing know-how and transferring technologies from information-rich regions to information-poor regions in the wake of a disaster. CBDP approaches have often used information communication technologies to enhance disaster communication (Mathbor, 2007). Thus, disaster preparedness and mitigation strategies need constant remodeling, and this study attempts to develop and showcase a "social network approach" as a tool for disaster mitigation efforts.

According to social network theory an increase in social ties in communities is highly correlated to higher social support. Social ties act as a conduit through which communication, interaction, and support flow (Patterson, 2009; Putnam, 2002). In disaster research, the exploration of social ties and social support as a possible tool for disaster mitigation and relief planning is comparatively new.

This chapter focuses exclusively on natural disasters, given their impact and frequency in recent times. Natural disasters are higher in impact than man-made disasters; for example, the gas leak tragedy that occurred at the Union Carbide plant in Bhopal, India, in 1984 and killed over a thousand people was a man-made disaster, a disaster also known as a technological disaster. A natural disaster has been defined as the effect of a natural hazard such as a flood, tornado, hurricane, volcanic eruption, earthquake, or landslide that leads to environmental and human losses (see United Nations International Decade for Natural Disaster Reduction 1990–1999 [UNIDNDR]) (U.N. General Assembly, 1987). Recent research has repeatedly attested to the fact that social support and social ties positively influence disaster response in urban and rural communities (Albanese et al., 2008; Hopmeier et al., 2010; Itzhaky & York, 2005; Mathbor, 2007; Mohan & Stokke, 2000; Norris & Stevens, 2007; Pfefferbaum, Reissman, Pfefferbaum, Klomp, & Gurwitch, 2007). Norris (1999) showed that during Hurricanes Hugo and Andrew residents who reported higher social support and larger kin or friendship networks were evacuated faster from the disaster zone than those who had minimal social support. Social support also acts as a protective factor against trauma caused by experiences with disaster (Brewin, Andrews, & Valentine, 2000). Anxiety over uncertainties surrounding the availability of vital services and over emotional support elevate stress levels for disaster survivors. Under these circumstances, having social ties not only helps dissemination of information related to available services in the affected areas but also provides social support (Millard, 2010; Norris, 2005).

Thus, it is important to coalesce divergent concepts such as social capital, social support, and social networks to create integrated and comprehensive disaster management models. The proposed model takes a relational approach (Wasserman & Faust, 1994) to underline the importance of social interactions at different system levels (individual, family, organization, neighborhood, and community) and calls for identifying and using benefits emerging from such interactions for disaster management and mitigation. The model defines community structure as interactive networks of interconnected nodes (Field, 2003) of individuals, families, and institutions that generate social capital essential for disaster preparedness and response (Mathbor, 2007).

We apply concepts of social networking to disaster management and mitigation. Likewise, we explore social networking across personal, social, and organizational levels and how it influences norms such as social capital and social cohesion, which are essential to the development of collective efficacy in communities. Drawing on the literature and an evaluation of multitheoretical approaches, we argue that community efficacy determines how neighborhoods respond to disaster before and after it strikes. Although the model discussed in this chapter is applicable to a wide range of disasters, it is illustrated by a case study of Hurricane Katrina.

Relational Aspects of Disaster Planning

Previous research has found that response to disasters is influenced by a variety of reasons and complex factors. Resources, disaster awareness, history, and the existence of social movement within a community are some of the factors presented in the literature (Violante, Kivlehan, & Flores, 2010; Yost, 2008; Zhang, Lindell, & Prater, 2009). However, community attitude and interest in disaster planning and response seem to vary from one area to another depending on the nature of the disaster and the type of perception developed and maintained within the community. Soliman (1995) suggests apathy and lack of interest as reasons for the lack of participation in disaster planning and response.

In rural communities, apathy and attitude toward the environmental movement seem to influence a community's ability to address disaster and to consider it as a threat to its stability (Soliman, 1996, 2005; Yost, 2008). On the organizational level, Gillespie, Murty, and Robards, (2000) found that agencies can raise the level of concern and interest in disaster planning if there is a specific motive and public interest in anticipating a certain disastrous event. Such interest may diminish once the concern is gone. This means that disaster planning within

organizations is fragmented and may suffer from a lack of consistency (Webler & Lord, 2010).

Moreover, an advance level of interorganizational planning (Gillespie, Murty, & Robards, 2000; Patterson, 2009) may be compromised if local communities and other stakeholders, such as individuals, families, groups, and formal and informal neighborhood agencies, are not taken into consideration at all levels of disaster mitigation and response. This lack of dialogue across different stakeholders contributes to inconsistency in disaster awareness and segregates disaster planning from community networks and their interactive resources (Itzhaky & York, 2005; Millard, 2010).

During the United Nations International Decade for Natural Disaster Reduction (1990–1999) the focus of disaster management shifted from postdisaster response to predisaster preparedness (Arya, 2002; Nakagawa & Shaw, 2004; Rock & Corbin, 2007). Experiences gained from Hurricane Katrina and the earthquake in Haiti underlined the risks of relying exclusively on government agencies. They have also created a need for multidisciplinary approaches to disaster mitigation and planning (Hopmeier et al., 2010; Millard, 2010; Patterson, 2009). There is an ongoing need for new approaches to involve communities in disaster planning by identifying new research and updated conceptual frameworks.

In addition to finding technological solutions to problems associated with disseminating advisories faster there is a need to strengthen the physical infrastructure, minimize damage from disasters, and legislate policies that will provide adequate funding for relief and response mechanisms (Daughtery & Blome, 2009). According to Arya (2002) disaster planning involves both mitigation (risk analysis, prevention, and preparedness) and response (search and rescue, humanitarian assistance, and rehabilitation and reconstruction), but the physical and infrastructural losses often overshadow the social aspects of disasters. Thus, even after the physical recovery process, communities often fail to recover from the frayed relational ties (Soliman, 1995; Thomas & Soliman, 2002).

Traditionally research on disasters has focused on the loss of physical and human capital and has advocated for response measures aiming at minimizing damage to physical infrastructure and human life (Dynes, 2002; Webler & Lord, 2010). There is no unequivocal definition of relational social capital since researchers vary in their opinion of the exact constituents of relational social capital. But a majority concur that there is an embedded value in community social networks, and if properly nurtured these networks can yield sustainable resources and resilience for the community in solving problems (Longstaff, 2005; Ritchie & Gill, 2007; Schellong, 2007; Violante et al., 2010). Although relational social

capital theory has not been widely employed in disaster research, theoretical approaches akin to social capital have been used in research, such as in the studies of the Buffalo Creek flood in West Virginia in 1972; the toxic contamination in Legler, Jackson Township, New Jersey, in 1971–80; and the *Exxon Valdez* oil spill in Alaska in 1989 (Arata, Picou, Johnson, & McNally, 2000; Edelstein, 2004; Gill & Picou, 1991; Patterson, 2009).

Multitheoretical Framework

A social network approach to disaster planning requires us to seek a multitheoretical framework in order to develop a holistic perspective that includes social network–based theories from different disciplines (Putnam, 2001). While social network theory constitutes the structural backbone of the model, related theories and perspectives have been incorporated from the literature so that a cohesive model relating specifically to disaster planning can be developed (Webler & Lord, 2010). A literature review of social networks and disaster brings up a variety of terms, such as *social support, social cohesion, social network, social capital, collective action, collective efficacy, community participation, civic participation*, and so on (Millard, 2010; Yost, 2008). These terms are related but not similar in meaning, making it difficult to understand their interrelationships and explore the thin line that divides them—a task critical to completing a comprehensive assessment of the influence of these so-called social variables in disaster planning. In this section we introduce these theories independently and underline their possible differences. Later we will connect these theories to the conceptual model proposed in this chapter.

Social network theory posits that the social ties of community actors, which include individual residents, families, and community-based organizations, define the basic structure of communities. The value of social ties rests on the relational qualities of communication between community actors. When two community actors are involved in a sustained interaction it is called a dyadic tie, whereas if more than two community actors are involved in such a communication web, it is called a triad or even a social network. Social ties can be either weak or strong depending upon the duration and quality of the interaction (formal/informal). Social networks provide communities with a structure in which actors interact. Thus, from a structural perspective, communities should be viewed as fluid spheres of social interaction rather than as fixed and discrete entities (Mohan & Stokke, 2000). According to social network theory, as the frequency of communication/interaction

between actors increases across social networks it generates certain norms, values, and qualities known as social capital and social cohesion.

As evident in the nomenclature, social capital indicates that there are "capital" values that underlie our social relationships. This is also referred to as relationship capital or relational social capital in the literature. Putnam (2001) found intrinsic resources within social relationships, between individuals connected to social institutions through volunteer activities and between informal and formal institutions. Informal institutions refer to neighborhood groups, local clubs, and syndicates of informal community groups; formal institutions refer to service providers, nonprofit and for-profit organizations and public agencies. Such participation over time generates social cohesion and social capital characterized by high levels of trust, social and instrumental support, and most important faster information dissemination across communities (Putnam, 2001).

Thus, social capital and social cohesion represent norms and values when there is a certain degree of interaction across social networks. Social capital assumes different characteristics depending upon the structure of the network in which social interaction takes place (Burt, 2000; Dekker & Uslander, 2001; Fukuyama, 2001). Bonding social capital refers to a closely knit, homogeneous social network that is low on diversity and high on trust and cultural bonding. Actors in this network share a history of identification and familiarity with one another. In contrast, bridging social capital relies on more open-ended social networks that are diverse and involve larger "floating populations," such as visitors from other networks. Bridging social capital is usually characterized by low trust and a greater supply of useful information. They also differ in the type of social support they generate. For example, bonding social capital generates more emotional social support, such as having someone to confide in, whereas bridging social capital provides instrumental social support, such as money or other forms of material support.

Similar to social capital, social cohesion is a latent structural element of social networks. Social cohesion refers to how individual actors can influence the behavior of groups and is concerned with group characteristics rather than individual ones. For example, high positive social capital of individuals can prepare a group to act cohesively toward disaster relief. Social cohesion also identifies the number of actors in a group or community whose removal could bring down the cohesiveness of the group (Festinger, 1950). The idea of social cohesiveness, properly understood, could provide valuable insight into why some communities demonstrate better group behavior in the aftermath of a natural disaster than others. Thus, social cohesion is an outcome of

social capital as well as a precondition of group behavior that generates social capital.

Social capital and social cohesion are determinants of collective efficacy, which should be considered an important resource when dealing with large and complex problems such as natural disasters (Bandura, 2004). Collective efficacy is the ability of a community to come together and employ concerted efforts to meet environmental challenges (Bandura, 2004; Benight, 2004). Benight (2004) defines collective efficacy as "the shared belief that a group can meet environmental demands and improve their life through concerted efforts" (p. 402). According to Bandura (2004), collective efficacy requires a shared belief and "judgments about group capabilities to make decisions, to enlist supporters and resources, to devise and carry out appropriate strategies, and to withstand failures and reprisals" (p. 451).

Collective efficacy and social capital create conditions for community collective action, which is significant in disaster response, especially regarding vulnerable groups such as the elderly, disabled, and extremely poor. In a natural disaster collective efficacy allows a community to make a concerted and coordinated effort toward recovery (Benight, 2004). Research further suggests that some degree of community efficacy depends on community competence, levels of economic development in the community, and the frequency of interactions in both formal and informal social networks. Collective efficacy enhances coping mechanisms in a community.

These mutually exclusive theoretical concepts are used here to develop a conceptual model that posits the complementary roles of these competing theories in disaster planning, preparedness, mitigation, and response and thus avoids potential conceptual redundancies and confusion. These theories/perspectives underscore the potential of relational ties in social networks and the mechanisms that bring about collective action during a natural disaster.

Along with the explanatory theories described in the section above the network model uses the system perspective to describe the structure of a community as a combination of networks of social relationships among actors. These networks involve actors from the microsystem (individuals, peers, family member, etc.), exosystem (nongovernmental organizations, schools, mass media, and private enterprises), and macrosystem (culture, political system, society, nationality, etc.) (Patterson, 2009; Robbins, Chatterjee, & Canda, 2005). The aim of this model is to contribute to the development of interventions for disaster planning and mitigation by using the relational resources from the social networks in communities (Buchanan, 2003; Rock & Corbin, 2007; Violante et al., 2010).

Figure 2.1 depicts a logic model that has three components: input, or the action that happens naturally or through intervention in communities; output, the immediate results of such natural actions/interventions; and outcomes, the short- and long-term consequences of those inputs and outputs.

Input: During emergencies people look for "similar others to help them make decisions on appropriate behavior" (Norris & Stevens, 2007, p. 323). Information on evacuation advisories, temporary refuge, and other resources for evacuation from private and public sources are available to people primarily through diverse social networks. Hence, investing in social networks and nurturing social ties are important measures for sustainable disaster preparedness (Daughtery & Blome, 2009). In a network model, social networking or interactions among actors and members of the community would be considered input if the final goal of the model was to attain the potential of relationship capital for disaster planning. For example, in Haiti such a measure has recently been undertaken to optimize usage of limited resources (Millard, 2010). This stage of the model informs an evaluation of the structural interaction among actors at the personal, support, and providers' levels.

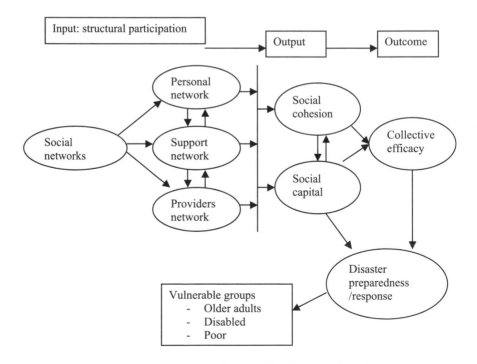

FIGURE 2.1 *The network model for disaster planning*

Social networks in a typical community can be divided into three types depending on their relevance to disaster preparedness and planning. These are personal networks, support networks, and providers' networks. Personal networks include an individual's friends and relatives. The diversity in personal networks ensures the flow of vital information and advisories related to natural disasters. Personal networks typically shrink with age and retirement, making elderly people especially vulnerable to disaster (Tyler, 2006). The size and quality of personal networks also indicate the potential social support that an individual might receive. The degree of social support at both the emotional and instrumental levels depends on the quality of social ties within communities among individuals, groups, and community-based organizations. However, when disaster strikes all support networks are themselves decapacitated and providers' networks step in from outside to continue the supply of support. Providers' networks include aid agencies like the Red Cross, the Federal Emergency Management Agency (FEMA), and other governmental and nongovernment support providers. Thus, the input section of the model explores the patterns of the connecting ties and their influences across personal, support, and providers' networks among community actors.

Output: Under certain conditions, structural participation generates social capital and social cohesion in communities. The output section of the model explores the norms of social capital and social cohesion generated by the input of structural participation. The impact of the model on disaster mitigation and response would depend on what kind of communities are affected. The model suggests that a community that is cohesive with high bonding and bridging networks will differ in its response from one that is diverse and noncohesive with weak ties and many social isolates (Wasserman & Faust, 1994). For example, soon after the Indian Ocean tsunami in 2004 the cohesive fishing communities in Thailand, most of whose members are Muslim, coordinated better with the international relief agencies in disbursing materials, cleaning up sites, and even generating money from the financial donors of other countries in the relief work in their neighborhoods than the mixed tourism-fishing communities with a higher migrant, floating population. These latter communities responded in a less-unified way to international donors, resulting in poor resource utilization (Rigg, Law, Tan-Mullins, & Grundy-Warr, 2005).

High social cohesion in the fishing communities was based on the strong social network ties in place before the tsunami. Moreover, soon after the tsunami, they used not only the relational capital of their internal social ties to coordinate relief and response within their communities but also the bridging ties that became available to them through

the participation of international relief organizations and transnational donors. Thus, preexisting bonding networks within communities could extend to transnational bridging networks once they were available. This progression is natural if social capital produces high social cohesion.

In a recent example from the 2010 earthquake in Haiti, where pledged international relief was not delivered on time, such bridging networks could not become established; as a result, in contrast to the example above, the bridging ties and associated social cohesion could not develop in Haiti. As a consequence there has been an increase in looting and other types of damage to vulnerable victims of the disaster, including older adults, women, and children. If not aided by resources and organization, social ties and social capital can turn into a negative force and lead to anarchy, the exact opposite of social cohesion.

Outcome: The final section of the model indicates that social cohesion leads to collective efficacy that enhances disaster relief efforts by generating collective action.

Hurricane Katrina: A Case Illustration

The components of the above model have been applied to a case study of Hurricane Katrina, one of the costliest and deadliest natural disasters in the history of the United States.

CASE STUDY

Hurricane Katrina was one of the costliest and deadliest natural disasters in the history of the United States. On August 28, 2005, the National Weather Service field office in New Orleans predicted catastrophic damage to the city of New Orleans that would render the city uninhabitable. The night before, on August 27, the National Hurricane Center had specifically informed local, state, and national administrators about the severity of the hurricane. The residents of New Orleans have always been aware of the vulnerability of their city due to its low elevation and likelihood of being hit by seasonal hurricanes (Brinkley, 2006). The vulnerabilities involving the levees and the low elevation constituted risk factors well known to the residents of every section of the city, and there were regular discussions about a possible doomsday scenario when levees would break and the city would be under water. The residents of New Orleans also knew about the millions of federal dollars that had been earmarked for reconstruction of the levees, work that was ongoing.

During previous decades, New Orleans had seen a gradual migration of economic activities from its shore to other, relatively new southern cities such as Houston, Texas, and Atlanta, Georgia (Rose, 2007). Manufacturing jobs and business activities involving the port had been drastically reduced, making tourism the economic mainstay of the city. As a result, unemployment and crime rates were up, community participation down, and the city had become increasingly segregated along class/race lines (Baker & Refsgaara, 2007).

On the evening of August 27, 2005, officials of the city of New Orleans issued a voluntary evacuation order that was subsequently upgraded to a mandatory evacuation the following morning. About one million people had indeed moved out, though a considerable number of people (around twenty-five thousand) remained in the city (Rose, 2007) due to lack of resources and of awareness of the disaster. The local authorities indicated that the levees might break and appealed to the residents of New Orleans to leave the city. However, poorer sections of the community and the older population remained, unaware of the advisories. Those who did know about the advisories decided to ignore them and stayed put at their own risk. Earlier experiences with evacuation, such as during Hurricane Ivan in 2004, had been stressful to older people and many fell sick during the evacuation, which, in turn, made them skeptical this time around. Thus, following Hurricane Katrina and to the astonishment of the authorities, many residents had to take shelter in the Louisiana Superdome. Around fifteen hundred people lost their lives, and the majority of them were poor and elderly. Soon after the hurricane's passing, New Orleans had spun into utter chaos, and incidences of looting, rape, and rioting were reported. Thus, New Orleans gradually started slipping into the heart of darkness after the natural disaster had passed through it (Brinkley, 2006; Rose, 2007).

Implications

Hurricane Katrina exposed many holes in the nation's disaster response mechanisms, especially FEMA, which came under intense attack from the media and other groups for being inefficient in its response to the disaster. However, when viewed through the lens of the network model Katrina simultaneously exposes the glaring lack of social cohesion and social capital in certain sections of the community, especially once anarchy broke out (Baker & Refsgaara, 2007). As the case study illustrates, New Orleans has been lauded for its success in evacuating a record number of people before the disaster and criticized for failing to reach out to approximately twenty-five thousand people who stayed and faced the disaster. An examination of the demographic profile of

those that stayed reveals a high degree of vulnerability, related to, for example, age, disability, poverty, and social isolation.

The case study raises several questions pertinent to the network model, including Why did a section of the community that knew about the impending disaster not comply with the advisories? Did the advisories reach everybody on time? How many residents could not leave because of mobility constraints? Did they know about the social support that existed in their own community?

The case study refers to changes in economic conditions in the New Orleans area, fueling an increase in tourism and other temporary attractions and spurring the development of "floating communities." As a result, the city consisted of communities that had strong ties between people with similar characteristics, that is, homophilous networks, rather than ties between people with dissimilar characteristics, that is, heterophilous networks (Haines, Hurlbert, & Beggs, 1996). Stunted economic growth and a lack of sustained economic activities contributed to poverty and splintered neighborhoods along race and class lines. In addition, significant differences in language, culture, and lifestyle among a diverse group of people including immigrants from the Caribbean, native Hispanics, and immigrant whites resulted in disconnected bubbles of bonding ego networks that nurtured deep mistrust between groups.

Because of its long history of hurricanes and floods and especially vulnerable location, New Orleans had a considerable number of relief organizations such as the Red Cross and United Way that had been offering emergency preparedness programs. However, there was a significant disjuncture between the social support network within the communities and the providers' network. Furthermore, because of the floating nature of the population, the degree of attachment to the community was minimal; in sum, it is apparent that before Hurricane Katrina, New Orleans lacked cohesive structural participation between different social actors (individuals, families, groups, and organizations). When placed in the context of the network model, this suggests that the social network input at different levels was low.

As a result, the output of social capital and social cohesion could not reach its optimal level, which in turn interrupted the dissemination of information on crucial matters like evacuation. The case study indicates that a large number of elderly and disabled people had deliberately refused the evacuation advisories from the mayor, choosing instead to rely on the wisdom of their respective homophilous networks. Consequently, when the disaster struck and personal and social infrastructure support collapsed, the providers' network could not reach the victims. Thus, collective efficacy was restricted and could not be used to meet the challenges presented by the disaster.

In addition, the network model suggests that in constructing aid relief that incorporates local knowledge and experiences into disaster mitigation plans, considerable efforts have to be given to connect local institutions to a wider network of organizations. This would be the only way to promote mutually supportive social networks and prevent loss of social capital.

Practical Advice

The relationship between social networks and disaster planning is nebulous and indirect. As a result it is important to define it in operational terms so that disaster mitigation professionals at the grassroots level can develop strategies for implementing the components of the model. The practical advice given here does not follow a chronological flow. Rather, it recommends that workers adapt the steps according to their needs on the ground. The following actionable steps, however, encapsulate the theoretical notion explained throughout the chapter. The steps could be taken immediately before or in the immediate aftermath of a natural disaster.

1. Create informal forums to increase interactions and sharing among survivors and arriving disaster relief workers. Identify community leaders, residents, victim families, local volunteers, local business owners, and other community-based resource persons.
2. Create and locate support groups to facilitate interdependent communication among support organizations (local, national, and international). Connect community-based individuals with other support organizations. Use disaster communication technologies such as ham radios and solar-powered Internet access.
3. Identify provider networks (both community based and outside) for relief materials and aid and connect them with personal and support networks to avoid confusion in aid distribution. A tripartite partnership of personal, support, and provider networks with an informal and active communication network is important for incorporating the network model. It requires long-term partnerships between private and public institutions to develop empirical modules of effective interventions in preemptive disaster planning.
4. Participate in traditional and new media platforms to maintain the momentum across bridging networks. Involve people and organizations from outside local areas to generate a snowball effect that could bring associated support networks to participate in disaster relief.

5. Community-based cultural and educational activities conducted by volunteers and victims alike should be regularly organized in relief camps and at other makeshift habitations.
6. Community-based information dissemination sessions should be regularly conducted.
7. Identify and promote any victim- and resident-driven initiatives. These initiatives may relate to community reorganization and restructuring efforts. Be ready with referral information on funding, advisories, and resources.
8. Monitor and evaluate social capital indicators like meetings, interactional incidence, volunteering, and collective efficacy on a regular basis and arrange strategies accordingly.
9. Involve representation of vulnerable populations and their advocates in group activities.
10. Create numerous smaller group networks (personal, support, and provider) instead of organizing larger groups.
11. Create consensus among divergent relief stakeholders to invest in social interactions.

By using the conceptual framework of the network model to inform and implement disaster relief efforts, the impact on vulnerable populations will be, it is hoped, lessened and communities strengthened.

References

Ablah, E., Konda, K. S., Konda, K., Melbourne, M., Ingoglia, J. N., & Gebbie, K. M. (2010). Emergency preparedness training and response among community health centers and local health departments: Results from a multi-state survey. *Journal of Community Health, 35,* 285–293.

Adams, L. M. (2008). Comprehensive vulnerability management: The road to effective disaster planning with the community. *Journal of Theory Construction and Testing, 12*(1), 25–27.

Albanese, J., Birnbaum, M., Cannon, C., Cappiello, J., Chapman, E., Paturas, J., & Smith, S. (2008). Fostering disaster resilient communities across the globe through the incorporation of safe and resilient hospitals for community-integrated disaster responses. *Prehospital and Disaster Medicine, 23*(5), 385–390.

Arata, C. M., Picou, J. S., Johnson, D. G., & McNally, T. S. (2000). Coping with technological disaster: An application of the conservation of resources model to the *Exxon Valdez* oil spill. *Journal of Traumatic Stress, 13*(1), 23–29.

Arya, A. S. (2002). *Earthquake disaster management in India.* Paper presented at the Workshop on Gujarat Earthquake Experiences: Future Needs and Challenges, Kobe.

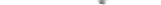

Baker, D., & Refsgaara, K. (2007). Institutional development and scale matching in disaster response and management. *Econological Economics, 63*(2&3), 331–343.

Bandura, A. (2004). *Self-efficacy and agency of change.* New York: Raven Press.

Benight, C. C. (2004). Collective efficacy following a series of natural disasters. *Anxiety, Stress and Coping, 17*(4), 401–420.

Benson, C., Twigg, J., & Myers, M. (2001). NGO initiatives in risk reduction: An overview. *Disasters, 25*(3), 199–215.

Brewin, C., Andrews, B., & Valentine, J. (2000). Meta-analysis of risk factors for posttraumatic stress disorder in trauma-exposed adults. *Journal of Consulting and Clinical Psychology, 68*, 748–766.

Brinkley, D. (2006). *The great deluge: Hurricane Katrina, New Orleans, and the Mississippi Gulf Coast.* New York: William Morrow.

Browning, C. R., Feinberg, S. L., Wallace, D., & Cagney, K. A. (2006). Neighborhood social processes, physical conditions, and disaster-related mortality: The case of the 1995 Chicago heat wave. *American Sociological Review, 71*, 661–678.

Buchanan, M. (2003). *Nexus: Small worlds and the groundbreaking theory of networks.* New York: W. W. Norton & Company.

Burt, R. S. (2000). The network structure of social capital. *Research in Organizational Behavior, 27*(1), 17–40.

Daughtery, L. G., & Blome, W. W. (2009). Planning to plan: A process to involve child welfare agencies in disaster preparedness planning. *Journal of Community Practice, 17*, 483–501.

Dekker, P., & Uslander, E. M. (Eds.). (2001). *Social capital and participation in everyday life.* New York: Routledge.

Dynes, R. R. (2002). The importance of social capital in disaster response. Preliminary Paper #327. University of Delaware Disaster Research Center.

Edelstein, M. (2004). *Contaminated communities: The social and psychological impacts of residential toxic exposure.* Boulder, CO: Westview Press.

Festinger, L. (1950). Informal social communication. *Psychological Review, 57*, 271–282.

Field, J. (2003). *Social capital: Key ideas.* New York: Routledge.

Fukuyama, F. (2001). Social capital, civil society and development. *Third World Quarterly, 22*(1), 7–20.

Gill, D. A., & Picou, J. S. (1991). The socio-psychological impacts of a technological accident: Collective stress and perceived health risk. *Journal of Hazardous Materials, 27*(1), 77–89.

Gillespie, D. F., Murty, S. A., & Robards, K. J. (2000). Clarifying coordination for disaster planning. *Disaster and Traumatic Stress Research and Intervention, XXI–XXII*, 41–60.

Haines, V. A., Hurlbert, J. S., & Beggs, J. J. (1996). Exploring the determinants of support provision: Provider characteristics, personal networks, community contexts, and support following life events. *Journal of Health and Social Behavior, 37*, 252–264.

Homeland Security and Justice Issues. (2010). *Disaster response: Criteria for developing and validating effective response plans.* (Publication No. GAO-10-969T). Washington, DC: Government Printing Office.

Hopmeier, M. J., Pape, J. W., Paulison, D., Carmonda, R., Davis, T., Peleg, K., et al. (2010). Reflections on the initial multinational response to the earthquake in Haiti. *Population Health Management, 13*(3), 105–113.

Itzhaky, H., & York, A. S. (2005). The role of the social worker in the face of terrorism: Israeli community-based experience. *Social Work, 50*(2), 141–149.

Longstaff, P. (2005). Security, resilience, and communication in unpredictable environments such as terrorism, natural disasters, and complex technology. *American Journal of Community Psychology, 23,* 631–656.

Mathbor, G. M. (2007). Enhancement of community preparedness for natural disasters: The role of social work in building social capital for sustainable disaster relief and management. *International Journal of Social Work 50*(3), 357–369.

Millard, W. B. (2010). Starting from scratch: Haiti's earthquake and disaster planning. *Annals of Emergency Medicine, 55*(5), 17A–22A.

Mohan, G., & Stokke, K. (2000). Participatory development and empowerment: The dangers of localism. *Third World Quarterly, 21*(2), 247–268.

Nakagawa, Y., & Shaw, R. (2004). Social capital: A missing link to disaster recovery. *International Journal of Mass Emergencies and Disasters, 22*(1), 5–34.

Norris, P. (1999). *Digital democracy: Do power sharing institutions work?* New York: Cambridge University Press.

Norris, P. (2005). *Radical right: Voters and parties in the electoral market.* New York: Cambridge University Press.

Norris, H., & Stevens, S. P. (2007). Community resilience and the principles of mass trauma intervention. *Psychiatry, 7*(4), 320–328.

Patterson, G. T. (2009). An examination of evidence-based practice interventions for public emergencies. *Journal of Evidence-Based Social Work, 6,* 274–287.

Pfefferbaum, B., Reissman, D. B., Pfefferbaum, R. L., Klomp, R. W., & Gurwitch, R. H. (2007). Building resilience to mass trauma events. In L. Doll, J. M. Bonzo, & D. Sleet (Eds.), *Handbook on injury and violence prevention interventions* (pp. 347–358). New York: Kluwer.

Putnam, R. (2001). *Bowling alone: The collapse and revival of American community.* New York: Simon & Schuster.

Putnam, R. (2002). *Better together: Restoring the American community.* New York: Simon & Schuster.

Rigg, J., Law, L., Tan-Mullins, M., & Grundy-Warr, C. (2005). The Indian Ocean tsunami: Socio-economic impacts in Thailand. *The Geographical Journal, 171*(4), 374–379.

Ritchie, L. A., & Gill, D. A. (2007). Social capital theory as an integrating theoretical framework in technological disaster research. *Sociological Spectrum, 27*(1), 103–129.

Robbins, S. P., Chatterjee, P., & Canda, E. R. (2005). *Contemporary human behavior theory: A critical perspective for social work.* New York: Allyn & Bacon.

Rocha, J. L., & Christoplos, I. (2001). Disaster mitigation and preparedness on the Nicaraguan post-Mitch agenda. *Disasters, 25*(3), 240–250.

Rock, L. F., & Corbin, C. A. (2007). Social work students' and practitioners' views on the need for training Caribbean social workers in disaster management. *International Social Work, 50*(3), 383–394.

Rose, C. (2007). *1 dead in attic: After Katrina.* New York: Simon & Schuster.

Schellong, A. (2007). *Increasing social capital for disaster response through social networking services (SNS) in Japanese local governments* (NCDG Working Paper No. 07–005). Amherst: National Center for Digital Government, University of Massachusetts.

Soliman, H. (1995). Rural communities' responses to the great flood of 1993: A tale of two cities. *Human Services in the Rural Environment, 18*(4), 36–41.

Soliman, H. (1996). Community responses to chronic technological disaster: The case of the Pigeon River. *Journal of Social Service Research, 22*(1–2), 89–107.

Soliman, H. (2005). Rural families' response to chronic technological disasters: The case of the Pigeon River. *Rural Social Work and Community Practice, 10*(1), 18–31.

Thomas, N., & Soliman, H. (2002). Preventable tragedies: Heat disaster and the elderly. *Journal of Gerontological Social Work, 38*(4), 53–66.

Tobin, G. A., & Whiteford, L. M. (2002). Community resilience and volcano hazard: The eruption of Tungurahua and evacuation of the Faldas in Ecuador. *Disasters, 26*(1), 28–48.

Tyler, K. A. (2006). The impact of support received and support provision on changes in perceived social support among older adults. *International Journal of Aging and Human Development, 62*(1), 21–38.

U.N. General Assembly, 42nd Sess. *Resolution adopted by the General Assembly, 42/169. International Decade for Natural Disaster Reduction* (A/RES/42/169). Dec. 11, 1987. Available at: United Nations Documentation: Research Guide, http://www.un.org/depts/dhl/resguide/r42.htm.

Violante, D. A., Kivlehan, S., & Flores, R. (2010, April). View from the ground. *EMS World Magazine*, 29–32. Retrieved from: http://www.emsworld.com.

Wasserman, S., & Faust, K. (1994). *Social network analysis: Methods and applications.* New York: Cambridge University Press.

Webler, T., & Lord, F. (2010). Planning for the human dimensions of oil spills and spill response. *Environmental Management, 45*, 723–738.

Yost, C. R. (2008). Improving responses to critical situations: Lessons learned from CWLA members. *Children's VOICE, November/December*, 22–26.

Zhang, Y., Lindell, M. K., & Prater, C. S. (2009). Vulnerability of community businesses to environmental disasters. *Disasters, 33*(1), 38–57.

Building and Maintaining Social Networks

Application of the Community Readiness Model

Kathleen A. Kost and Ruth W. Edwards

An important factor associated with a community's capacity to effectively respond to a disaster, particularly one that is resource poor, is the willingness of community leaders to engage local residents in the planning process. This chapter describes the use of the Community Readiness Model as an assessment and capacity-building tool that can be used to identify the social capital of leaders and residents as well as unique local resources and issues that need to be brought to bear in disaster planning. Identification of social capital assists practitioners in strengthening existing social networks and creating bridges to additional sources of support that can be used in times of crisis. Involvement of local leaders and residents in a planning effort enhances the potential for success when disaster strikes.

Social capital is located within, between, and among people. It manifests in the trusting relationships individuals have with one another and in the considerable resources they are willing to bring to a collaboration effort. As an outcome of these relationships, social networks represent the bridges individuals build between their respective systems. Accessing the social capital within these networks to empower communities to address problems and challenges can be inhibited by structural barriers created over time by the community itself. Strategies for addressing these barriers and community-level problems that are beyond the

scope of the individual to solve can be created through the connections that are made across social networks (Putnam & Feldstein, 2003). Thus a community, as a collective agent, can not only reduce the practices and procedures that restrict collaboration in times of disaster but also, by utilizing the resources within social networks, improve the likelihood of mitigating the effects of a disaster.

Communities with strong social networks are able to "grow" concrete resources aimed at improving the overall quality of life and well-being of residents. Social networks are particularly important in disaster planning and mitigation since they provide conduits for information and resource gathering and dispersal. In a similar manner, residents who trust that the decision-making process of governing bodies and public institutions is responsive to their needs are more likely to invest in their community than those who feel neglected. Likewise, residents who are engaged in civic activity, be it as a volunteer or employee, are more likely to be concerned about the well-being of their community compared with those who are disengaged. In general, though, people are willing to contribute when they feel confident that their efforts will lead to the improvement of the safety, health, or security of their community (James, Schulz, & van Olphen, 2001).

In order to prepare for a disaster, both the leaders and the general population of a community must be aware of its potential. Unfortunately this often means that they may have previously experienced the impact of a disaster directly or indirectly on their infrastructure, incomes, and well-being. Realistically and practically, few communities are willing to engage in the discussion and debate over strategies to mitigate the results of a disaster, let alone commit scarce resources to this effort, if the potential risk is viewed as minimal and an occurrence remote. Consequently, it is critical for preparedness that residents be aware of the potential risks and thus recognize the need for an emergency plan.

Moreover, an adequate number of well-informed stakeholders who are able to convey a sense of urgency to the community must be committed to working with residents to develop a plan. Although emergency plans are typically initiated by city/county/government or nongovernmental officials, if a disaster response plan is truly to address the needs of all those potentially affected by such an emergency, it cannot be an exclusively top-down or bottom-up activity. Rather, the effort to develop a plan must detail linkages between and among a variety of traditional systems and institutions such as security/safety systems (i.e., police and fire responders, health-care providers, and whoever controls access to and treatment of water supplies); the human service system, including the relevant agencies or leaders in the nonprofit and

faith-based sectors; and key community individuals who may not nec-
essarily have a formal title or position. Informal groups such as volun-
teer associations and social networks must be invited and encouraged
to contribute to elements of a plan that is likely to impact groups that
may be marginalized in more formal settings.

A community's ability to respond effectively to a disaster, regardless
of whether it is natural, environmental, or social, is dependent upon the
linkages that have been created and sustained across a variety of sys-
tems. These linkages may take the form of access to traditional resources
such as money, evacuation vehicles, and shelters or intangible resources
that individuals bring to problem solving such as experience and exper-
tise in planning, organizing, and implementation. Likewise, in more
urbanized communities, community resources may be in the form of
opportunities presented by local zoning regulations and statutes that
foster cross-system collaboration.

Beyond the mechanism of establishing linkages across systems to
facilitate responses to a disaster situation, the cultural beliefs that are
held by community residents relative to a disaster such as an earth-
quake, tsunami, and so forth must be taken into account. Does local
folklore have an explanation for different types of occurrences that may
have disastrous consequences for a population? Does the explanation
reflect the helplessness of residents in the face of the event, viewing it,
for example, as punishment for something residents have done or not
done, the act of a spiritual being? Is there something that local residents
believe is successful in preventing disasters of various types? What are
the traditional ways of responding to disastrous occurrences?

An elegant plan for disaster preparedness, even one developed with
the participation of local residents, may not be successful if it ignores
local beliefs. While local folklore may not offer a scientific explanation
for why a given type of disaster occurs, it may provide practical guid-
ance for mitigating the disaster. For example, anthropologists credit
local folklore with saving the lives of most members of tribes living in
the Andaman and Nicobar Islands in the Indian Ocean at the time of
the devastating tsunami in December 2005. Knowledge passed down
through generations led tribal members to move to higher ground
when they felt the earth shake, thus avoiding loss of many lives when
the tsunami hit their islands (Shaumik, 2005).

Just as important as recognizing the contribution local folklore
may make to identifying mitigation strategies is understanding and
assessing whether a proposed mitigation plan will conflict with cultural
beliefs. An example of a well-meaning and scientifically sound preven-
tion effort that initially failed to take into account crucial relevant cul-
tural beliefs is the effort reported by Viste (2007) to introduce the use of

folic acid to prevent birth defects to Hmong refugees living in Wisconsin. At the time of the project, most of the local Hmong were recent immigrants, many of whom held traditional Hmong beliefs that, for example, birth defects could not be prevented. Anecdotal information gathered by the project staff indicated that some of the Hmong believed that birth defects occurred for reasons related to past acts or one's ancestors, such as an unpaid debt from the past or an ancestral curse. Initial efforts using directly translated birth defect prevention materials were in marked conflict with these cultural beliefs and not accepted as respectful, credible, or useful by Hmong nutritionists. With sensitivity to these beliefs, the project team was able to design a program not in conflict with cultural values and beliefs that achieved the desired results.

One method that has been used to identify the strength of social networks across systems and assess readiness to address problems at the community level is the Community Readiness Model (Edwards, Thurman, Plested, Oetting, & Swanson, 2000; Plested, Smitham, Jumper-Thurman, Oetting, & Edwards, 1999). Developed by researchers at the Tri-Ethnic Center for Prevention Research, this method relies on key respondents from a variety of local representatives who hold critical roles in public, nonprofit, and faith-based entities as well as informal leaders within a community who can accurately represent both the knowledge and awareness of their respective social networks on an issue.[1] By also including informal leaders who are members of the community at large, the method facilitates access to previously unrepresented and more often disenfranchised groups in order to determine the readiness of a community to create and successfully implement a plan that has widespread support. This model has been well received in communities of diverse cultures both in the United States and around the world addressing a wide variety of health, social, and environmental issues (Aboud, Hug, Larson, & Ottisova, 2010; Brackley et al., 2003; Carlson & Harper, 2008; Hull et al., 2008; Kennedy et al., 2004; McCoy, Malow, Edwards, Thurland, & Rosenberg, 2007; Ogilvie et al., 2008; Peercy, Gray, Thurman, & Plested, 2010; Scherer, Ferreira-Pinto, Ramos, & Homedes, 2001; Waga & Roberts, 2009).

This chapter explores the Community Readiness Model as a method of assessing, building, and sustaining strong social networks to develop and implement a plan for and mitigation of the effects of disasters faced by communities within their unique cultural contexts. The literature on relational organizing and community-capacity development is examined as a framework for accessing and building social networks that are essential to the model. Finally, how this method can be used in disaster planning and strategies for implementing the recommendations that are generated from the process are discussed.

Background to Model Development

An unexpected extreme event such as a natural disaster requires a response from a community to quickly and effectively meet the diverse needs of residents, particularly those that are considered vulnerable. Disasters often threaten the viability of core infrastructure, thereby stretching much needed but scarce resources to not only provide shelter to citizens but also repair and sometimes rebuild basic services essential in disease and mortality reduction. Systems theory, used extensively by community practitioners, suggests that communities are living organisms that operate in three primary dimensions that impact the success of mitigation efforts (Fellin, 1995). The first is structural and takes the form of formal agencies and institutions that oversee the physical elements of a community. They provide control and maintenance of essential services such as water supplies and sewage as well as the range of equipment and resources needed for ensuring the health, safety, and fire protection of residents.

The second dimension is function. Communities, whether large or small, through their structures perform activities that promote economic well-being and adherence to social norms and values. Consequently they function as agents of socialization, mutual support, and social control while they seek to foster social participation. Finally, communities evolve over time in response to the changing demands of residents, their environment, and outside pressures exerted by society. Although communities differ in many dimensions, including size and the degree of authority elected and employed officials have, they all make strategic choices regarding the use of precious resources, whether natural, financial, or human.

Likewise, communities differ in the level, quality, and stability of interdependence these functions have with one another and in their readiness to collaborate. In the wake of an extreme unexpected event, the public service systems of a community must have reached a sufficient level of readiness to collectively address such a crisis affecting the community and be able to quickly collaborate and cooperate with one another in sharing information and resources. For example, it is critical that public entities have mechanisms in place for quickly distributing both information and resources to human service systems that provide direct care to children, families, the elderly, and others. For doing so, emergency protocols and procedures that key personnel in public entities can quickly implement are critical to the survival of vulnerable residents. One such protocol that acknowledges the power and resources of social networks is the disbursement of information to a range of local organizational stakeholders such as the public school district, faith-based entities, and agency personnel such as those from the Red Cross

whose resources can be accessed when disaster strikes. Thus mutual reciprocity between and among public, private, and not-for-profit leaders is an important attribute when faced with a disaster and one that needs to develop over time. Because communities seek stability both in their structures and relationships with key stakeholders they often tend to focus more on the maintenance of current ties, processes, and contractual arrangements than on innovation and change.

Disasters are by definition extreme events that occur with little warning, and thus communities may be ill prepared for the adaptation in resource utilization needed to mitigate their effects. Critical civic functions and relationships may break down or no longer exist. As a consequence, access to information, needed services, and resources may be fragmented, thereby placing vulnerable residents further at risk.

The Community Readiness Model, through its use of key respondents representing multiple social networks, provides a mechanism for assessing available resources and identifying gaps in awareness, knowledge, and opportunities. This model is the culmination of a number of observations, experiences, and theories by researchers interested in finding solutions to widespread community social problems such as domestic violence, substance abuse, and adolescent suicide (Edwards, et al., 2000; Plested et al., 1999). Rothman's (2008) model of community capacity development is particularly helpful when conceptualizing how the Community Readiness Model can be used in a community. His model uses the strategy of consensus to build the skills and expertise of residents so that they have the capacity to solve problems collectively. The Community Readiness Model takes a strengths-based perspective in its approach to capitalizing on and growing the capacity of residents to coproduce a solution to a problem.

Community capacity development can take three forms: participatory planning, which relies on statistical information; capacity-centered development that seeks information from those most affected by a problem; and social advocacy, which uses pressure by constituents to influence development (Rothman, 2008). Of these three forms, capacity-centered development best describes the process the Community Readiness Model uses to identify and develop a plan specifying the work necessary for a community to survive a disaster. This model of development has three dimensions that are particularly important to the success of this work: cohesion, capability, and competence (Garvin & Tropman, 1998). Critical to the success of using the Community Readiness Model, however, is that communities and even subgroups within them in some cases must have a functioning identity that facilitates accessing these attributes as well as a collective social understanding that encourages and supports their action. Just as norms and values

shape individual identity, so too do community norms and values inform the identity of a community (Sampson, 2008).

The Community Readiness Model relies fundamentally on the capability of community residents and their respective social networks to identify existing resources in order to determine what may be needed to increase the success of its response to an unexpected event within their unique community. The concept of relational organizing in the field of community development is particularly important to an understanding of how the Community Readiness Model operates. Relational organizing developed out of the community organizing techniques of Saul Alinsky and the International Areas Foundation that he founded to advocate for the rights of workers in the 1930s (Stall & Stoecker, 2008). This type of organizing taps into the interest and energy within social networks by creating bridges between and among them to initiate community change efforts. At its most fundamental level relational organizing occurs through conversations and discussions among group members (Warren, 2008). Through these discussions members of a group or network share information and gain consensus not only on the definition of what a disaster may mean for residents but also on its possible effects and the need to formulate a plan that can be activated quickly.

The Community Readiness Model is somewhat analogous to the well-known transtheoretical model of individual change often referred to as the Stages of Change developed by Prochaska and DiClemente (1983). This model suggests that an individual's ability to change at the personal level is a process involving multiple stages (DiClemente & Prochaska, 1982). The model grew out of research on addictive behavior and was developed to assist clinicians working with clients on improving recovery outcomes. The authors posit that individual readiness for psychotherapy is an essential element for initiation and successful implementation of treatment (Prochaska, DiClemente, & Norcross, 1992). In other words, if a client is not ready to change the behaviors that support the addiction, treatment, even when mandated by the courts, will be ineffective and unsuccessful. This conceptualization provided an important framework for development of the Community Readiness Model, as did the literature and theoretical constructs of community capacity development and relational organizing. The Community Readiness Model suggests that, just as individuals will receive little or no benefit from treatment they are not ready to receive, if members of a community are not ready to acknowledge, for example, that there is a likelihood of a disaster striking locally and further that there is something that could be done to mitigate the consequences, even scientifically sound plans that may have demonstrated utility in other communities are not likely to be successful.

As a foundation for the discussion of the readiness stages identified in the Community Readiness Model, we first take a brief look at the simpler Stages of Change Model for individual receptiveness to change. This model is composed of five stages that do not necessarily proceed in a routine or predictable pattern. Instead, progress through the stages is entirely dependent upon the individual and the problem he or she is trying to resolve. The first stage of Precontemplation describes the individual who has no desire or interest in changing their behavior. The second stage of Contemplation suggests that the addicted individual is beginning to experience negative consequences of addiction and has some recognition that they may have a problem. It is at the third stage of Preparation that the decision to act has been made, and thus this is the stage where a plan is developed that will be implemented in the subsequent stage of action. The fourth stage is Action, where the new behavior is actually being practiced; in the case of addiction, the individual discontinues use of the substance. Finally, at the fifth stage, which Prochaska and DiClemente (1983) call Maintenance, the pattern of responses to addictive cues has been broken and the individual is able to access support and use behaviors that reinforce their health.

These personal stages of readiness bear some similarity to the process a community may evolve through as it recognizes and then changes the way it addresses a problem. However, since a community is made up of many individuals, characterizing the stages of readiness for a community must necessarily go beyond addressing individual change processes and incorporate an understanding of how communities function, develop, and change. It is intuitively clear that the client is the central figure in the transtheoretical model of change. This is similarly true for the Community Readiness Model of community change, but with more complexity. A community is an organism, not just an entity, and the importance of the involvement of community members and leaders in the process of raising awareness, planning, and implementing a disaster plan is as important to successful community implementation as is the client's centrality in the transtheoretical model of change.

A key difference between the two models, however, is that the Community Readiness Model relies on multiple dimensions to understand readiness in a community, with readiness levels assessed for each of the dimensions in a given community. These dimension-readiness scores break down the components of readiness, identifying how a community's energy and resources can be focused on efforts most likely to move the community forward in addressing the issue at hand. As in the Stages of Change Model, however, progress through the stages for each dimension may not proceed in a routine or predictable pattern. The process is entirely dependent upon beliefs, resources, challenges, priorities,

cohesiveness, and many other aspects unique to the community. Time spent in a readiness stage and ability to progress will also generally vary by issue within a given community. A community may be able to come together quickly to support an identifiable long-term community benefit such as an effort to protect or increase access to a clean-water supply. This is something that may be readily recognized as relevant to their daily functioning by the majority of residents. Preparation and planning for a disaster that has an unpredictable time frame may require more preparation and effort to rally widespread community support.

Elements of the Community Readiness Model

The Community Readiness Model identifies nine stages of readiness, six dimensions in which readiness is measured, a process for gathering information through key respondent interviews, and a set of anchored rating scales for assessing level of readiness in each dimension. In addition, in the years the model has been used the types of efforts that communities have found successful in moving from one stage to another have been documented and general descriptions are now included to help guide communities in planning their efforts. As noted, this model has been used to address a wide variety of issues but is discussed here with a focus on disaster preparedness planning. Adapting the Community Readiness Model to address disaster preparedness planning takes a somewhat different course than more traditional applications of the model where the "plan" is something that can be implemented and evaluated on a schedule of the instigators' choosing. The very nature of disasters is that they occur with little warning and are not "scheduled." The first six stages of the Community Readiness Model are the most relevant to preparing a disaster plan, but the remaining stages have relevance for the longer-term safety of a community through preparedness.

STAGES OF COMMUNITY READINESS

The first stage of the Community Readiness Model somewhat analogous to the Stages of Change Model of Precontemplation is No Awareness. At this stage there is a lack of acknowledgment of a need to plan and prepare for disasters. The idea generally has not occurred to residents in the community because the occasional disaster is seen as merely a part of life. The second stage, Denial/Resistance, is generally characterized by the belief among community members that there is nothing that can be done about a disaster striking and therefore there

is no need to formulate a plan. The label "Resistance" was added to this stage after developers of the model encountered an attitude in some communities that while still characterized by a belief that nothing should or could be done had an additional element of the determination of residents not to lose any personal freedom that collectively addressing the issue might require. Reasons for lack of willingness to change will likely vary by community and issue, but they must be addressed because they represent potentially serious obstacles to implementing any formulated plans. Some examples of possible reasons are that members of the community may feel the costs of preparations are too high or would divert resources from what they see as more pressing needs; proposed efforts may represent a deviation from traditional practices that may be seen as threatening group identity in some way; or as individuals or subgroups members may feel they will not personally benefit.

The third stage of readiness is called Vague Awareness and reflects a dawning awareness among at least some members of the community that preparation for mitigating a disaster is something that is of relevance to the community. There is beginning to be some recognition that something actually could and even should be done to plan for mitigation of a disaster that could reasonably be expected to occur in the community at some point in the future. However, there is no immediate motivation to actually do anything. At the fourth stage, Preplanning, there is a clearer recognition on the part of at least some in the community that something needs to be done to formulate plans for when a disaster strikes. At this stage, spokespersons or leaders are beginning to emerge, but efforts are not yet focused or detailed. Also at this point there is more an acknowledgment in the community at large that something needs to be done. The fifth stage is Preparation. At this stage detailed planning is under way. Resources are being actively sought, representatives of different agencies or service providers are coming together to collaborate on specific aspects of plans, and decisions are made on what roles each will have and how they will be carried out. Concrete plans such as how agencies will communicate with one another and with community members at large, if evacuation routes are necessary and what they will be, how emergency services will be provided, and so on are developed. The sixth stage is Initiation, the stage at which the plan is "rolled out." At this stage, training of relevant personnel may be under way, and plans are documented and available for dissemination. The plan is still viewed as a new effort and enthusiasm is generally still relatively high among the participants in the plan's development. Community support is at least modest with usually little active resistance to the plan.

The Stabilization stage in the Community Readiness Model could be construed as the stage at which the plan becomes accepted as a part of the community's resources that are there to help preserve the health and safety of residents. Activity in this stage might include routine checking of any materials and supplies that are necessary parts of the plan to ensure that they are in usable and deployable condition. Periodic meetings of key leaders and/or agency representatives should be held to ensure that relationships and roles stay current. Persons new to the network should receive training on what their role in the plan is and familiarize themselves with procedures and contacts they would need to carry out their roles. Means of educating community members about what to do in case of a disaster are in place, perhaps including a curriculum for giving information to schoolchildren. Generally at this stage limitations of the plan may be recognized, but there is no sense that there is a need to update the plan.

The last two stages of the Community Readiness Model are more relevant for continuing after a disaster has occurred and the plan has been implemented. In the eighth stage, Confirmation/Expansion, a complete evaluation of how well the plan worked and what needs to be improved can result in an improved plan to mitigate future disasters. When stage nine, High Level of Community Ownership, is reached, disaster preparedness is an accepted aspect of community life. Education about what to do in case of a disaster is widely available and common knowledge among community residents. When new techniques and lessons from other communities for disaster response become available, they are evaluated by community leaders and incorporated into the plan as deemed appropriate. If a disaster does strike, the success of the plan is evaluated and changes are made to better prepare service providers and residents to mitigate damage in future events.

DIMENSIONS OF COMMUNITY READINESS

The complexity of community functioning requires that assessing readiness be multidimensional. Breaking key elements of readiness down in this fashion also provides guidance for the particular type of efforts that need to be undertaken to move a community further along in readiness to address a specific issue like disaster preparedness. The dimensions that make up the core of the Community Readiness Model are as follows:

- Existing community efforts: To what extent are there any current efforts that would mitigate the effects of a disaster? Is there a plan? Who does what?

- Community knowledge of the efforts: Do community members at large know about any community resources that are available to help mitigate the effects of a disaster?
- Leadership: Is there any leadership (formal or informal) interested in or formulating a plan to mitigate damage from a disaster that might occur in the community?
- Community climate: What is the prevailing attitude toward creating a plan to mitigate the effects of a disaster? Is it one of helplessness, or is there a feeling of empowerment and responsibility?
- Community knowledge about the issue: To what extent do people in the community understand the cause or course of what might lead to a disaster and what might be done to mitigate damages?
- Resources related to the issue: What resources (people, time, funds, space, etc.) are there available in or to the community to help prepare and implement a disaster plan?

Process for Gathering Information

A series of questions designed to elicit information addressing each of the six dimensions is part of the Community Readiness Model. These questions are first adapted to specifically address the particular issue of interest. Once an adaptation has been made, it is important to pretest the interview to be sure that the issue is adequately defined and specific enough so that responders will be able to understand clearly what they are being asked and responses will be useful to the process. The number of interviews to be collected in a community is somewhat dependent on the structure and diversity of the community. In a small village, three or four interviews may be adequate to elicit a general understanding of the readiness level of the community at large. In a larger community with multiple service agencies and a more heterogeneous population, up to ten or even occasionally more interviews may be needed to ensure that information is collected that represents the attitudes, beliefs, resources, and so forth of the whole community. Those interviewed should represent different segments of the community's population. Often representatives are chosen from local service agencies such as health care and law enforcement, the clergy or key religious entities, local government, school systems, informal community leaders at large, and so on. It may be relevant to include representatives of different generations within the community as well. Developers of the model at the Tri-Ethnic Center stipulate that the identification of respondents should be relevant to the issue being addressed and that it is better to be more inclusive than exclusive in gathering information. In some cases it is necessary to conduct more interviews to increase the

confidence of the community that the assessment is valid and to avoid offending key individuals by not including them in the assessment. Typically, however, little new information is generated by conducting more than five or six interviews. The goal is to gather information about different segments of the community that need to be involved for successful implementation of whatever program or policy is being addressed. In the case of disaster preparedness, this would include the whole community, agencies and residents. Responses to the questions addressing each dimension are scored using an anchored rating scale to then determine the particular stage of readiness in each dimension. An overall readiness level for the community can be derived, but it is the individual dimension scores that are of most use in guiding strategy development and implementation.

As a collection of individuals and families, communities seek certainty in their environment and relationships and thus develop a civic infrastructure that can respond to community problems and the needs of residents. Cohesion in community norms and values can act as a catalyst for change or lead to inertia and the maintenance of the status quo. When this civic infrastructure functions as a reflection of the community's shared identity, norms, and values it can sustain development and create the mechanisms needed to mitigate the effects of an unexpected event such as a disaster (Traynor, 2008). However, if the residents of a community are disengaged or feel powerless to act, they may not be able to exercise the competence needed to initiate collective action. In this case, when faced with a disaster individual members may simply fend for themselves, unaware of the resources available to them from the wider society.

Much depends upon the community's capability to accurately and adequately assess risk in the environment. The process itself is frequently instrumental in advancing readiness of a community to address an issue. As questions are asked and information is gathered, the trust level of residents that their opinions and knowledge are valued by the entity or leaders interested in developing a disaster plan for the community often increases significantly. This process can also create more investment and ownership in the eventual plan, which will facilitate community-wide acceptance and make it more likely the plan will actually be implemented as designed when disaster strikes. Especially when the instigating entity for disaster planning is not from within a community but rather is a national or regional agency of some sort, the information gathered during the interview phase is frequently critical and extremely valuable in tailoring a plan to the unique needs and culture of a community.

When effective, this assessment activates the many social networks operating within a community. The success of the response of these

networks depends upon the structural constraints and opportunities that constitute and influence the operation of core community functions (Sampson, 2008). When key leaders distrust or disregard the impact of their decisions on one another, essential information may be inadvertently withheld regardless of the consequences for residents. For example, if the head of the health department does not consider informing the chief of police about the risk of disease or pollution of the water supply, the police department may inaccurately assess the number of officers needed to ensure the safety and well-being of residents seeking medical care, clean water, or temporary shelter. Overlooking the cooperation and reciprocity needed between the public and private sectors also undermines the ability of institutions to act collectively to ensure the safety and well being of residents.

Once a stage has been identified, a strategy appropriate to that level of readiness is chosen. At lower levels of readiness, the strategies would focus efforts on not only increasing awareness of the problem but also, in the case of a disaster, on including diverse members of the community in the development of mitigation efforts.

Table 3.1 shows the stages of the model, identifies some of the behavioral indicators of the stages, the intervention goal of each stage, and a typical type of strategy that can be used to create change and movement to the next stage. When this content is applied to disaster planning, the behavioral evidence for the stage of No Awareness can be found in a resignation on the part of residents that this is just the way things are and that there is nothing they can do to prevent a disaster or mitigate its effects. The goal at this stage is to raise awareness. One strategy recommended to achieve this is to meet with key leaders as well as influential groups to encourage their interest in an effort to plan a response to a disaster. The stage of Denial may be evident if residents generally ignore or discount the potential effects of a disaster.

As Table 3.1 suggests, these strategies start with the simplest level of networking, one-on-one contact. These are then followed by networking within existing groups and creating networks between groups such as service providers and public entities by including them in the planning process. A cooperative planning process can then lead to more complex and in-depth efforts to create service agreements and provide advanced training to professionals and first responders. Evaluation of change efforts through an informal reassessment of readiness levels in each dimension is recommended at every stage so as to guide organizers on whether the community is ready to move to the next stage and more advanced strategies can be initiated or if practitioners should continue their current level of efforts, perhaps refocusing them on dimensions where readiness is still low. Although the types of strategies

TABLE 3.1
Examples of relevant behaviors, goals, and strategies for the Community Readiness Model stages of change

Stage	Behavioral indicator	Goal	Strategy
No Awareness	Issue is not generally recognized by leaders or the community as a problem	Raise awareness of the issue	Visits and calls to community leaders, friends, and small, existing groups
Denial/ Resistance	Nothing needs to or can be done locally	Recognition that issue is relevant to the community	Use low-intensity but visible media such as fliers and posters and write articles for newsletters and bulletins
Vague Awareness	Recognition that it is a problem but no immediate motivation to do anything about it	Raise awareness that the community can do something	Conduct informal surveys about attitudes and perceptions among residents and hold events where information can be distributed
Preplanning	Discussion but no real planning	Develop concrete ideas	Conduct focus groups and increase media exposure; identify the outcomes of previous disaster response efforts
Preparation	Leaders begin planning in earnest; community offers modest support of efforts	Gather information to plan new and improve existing programs	Use key leaders to speak to groups about local facts and challenges; sponsor kickoff event to attract more residents to give more input
Initiation	Enough information is available to justify efforts and activities are under way	Provide community specific information	Expand networking among service providers and community systems and formalize these with service agreements
Stabilization	Activities are supported by administrators or community decision makers; staff are trained and experienced	Stabilize efforts and programs	Provide advanced training to professionals and first responders; continue community events to maintain awareness and support

| Confirmation/ Expansion | Standard efforts are in place; community members are comfortable in using services and support expansions | Enhance and expand services | Use evaluation of the effectiveness of the plan after implementing it in response to a disaster to expand efforts and provide feedback to the community; continue media outreach to inform public on specific trends that may impact disaster response |
| High Level of Community Ownership | Detailed knowledge exists about prevalence, risk factors, and causes; effective evaluation is in place | Maintain momentum and continue growth | Diversify funding resources and conduct evaluation to identify need for changes to the plan and additional training needs |

Note. Adapted from Plested, Edwards, & Jumper-Thurman (2004); McCoy et al. (2007).

for building support are defined generically by the Community Readiness Model, these can be easily adapted to fit both the community's unique culture and the processes it uses to solve a problem (Scherer et al., 2001). Because this method is grounded in the community's culture, strategies developed are more likely to use the problem-solving traditions and heritage of residents and lead to more success in coproducing a solution that all parties can implement.

Using the Model in Resource-Poor Communities

One of the many challenges that residents of resource-poor communities or a neighborhood within a community face is their limited access to information, services, and resources. Placing this challenge in the context of system theory suggests that the borders of these types of communities are more closed than open, less permeable regarding the ease with which information and resources can be accessed by residents. Sometimes this is a function of their isolated location, such as communities in rural or frontier areas where there is limited or no access to public transportation or paved roads. Other times this limitation may be a function of the oppression and marginalization that residents have experienced at the hands of the government or more powerful segments of the community. These barriers may be institutionalized through routine government procedures and practices that limit or even prevent the involvement of marginalized groups in community-level problem solving.

The literature on community capacity development suggests it may be difficult to create a disaster plan and expect success in implementing it when there is a high degree of mistrust by residents of a government effort to "help" them. This is particularly true when residents have a history of being impacted by the failed efforts or broken promises of government. While the Community Readiness Model or indeed any approach may be challenging in this case, this is the very situation and set of circumstances where the Community Readiness Model can be particularly helpful because of its focus on cultural awareness and its recognition that solutions can be coproduced when the interests of all segments of a community are represented.

As noted, emergency response planning is usually initiated by government officials who are likely to replicate the decisions and processes that marginalize groups or neighborhoods, inadvertently assigning them the status of consumer or recipient but not leader. If responses to an assessment of community readiness indicate that the community or a group within the community does not trust that their needs have been or will be addressed in the development of mitigation plans, then it is incumbent upon the organizers of this effort to work with key representatives of the disenfranchised group. Critical to the successful implementation of the Community Readiness Model is the existence of a genuine effort and willingness on the part of the initiating group to listen and learn from individuals and groups in the targeted community.

Key to this involvement is the acknowledgment that disenfranchised groups often have created community-based networks, however informal in nature, that not only provide needed services to members of the group but also represent their interests in the larger community. Given the risks to survival associated with an extreme event, it is critical that organizers of the disaster planning effort focus their efforts on inclusion of representatives of these groups at every stage of the process. These efforts may need to move slowly and at first address an issue that the marginalized group is most concerned about, even if its relevance seems peripheral to the disaster planning effort, in order for these representatives to feel confident that their interests are being served. How this is done is dependent upon the experience that residents have had with previous efforts, which may have harmed them rather than kept them safe. When such a negative climate exists, the Community Readiness Model assessment will indicate a low level of readiness and suggest that planning efforts begin with individual contacts before proceeding to more formal activities such as focus groups and presentations by trusted representatives to increase awareness of the community's efforts to plan for the evacuation, sheltering, and security of residents. This methodical approach to building relationships allows practitioners

to educate residents about the potential risks and learn of special circumstances that are relevant to planning in each unique community. Through this process, practitioners can communicate the importance of inclusion of local community members in the planning process as well as the need for them to have shelter and evacuation information readily available in advance of a disaster.

In this regard, it is essential that organizers of this effort acknowledge the role that social and cultural capital play in facilitating access to diverse social networks and commit to being sincere and open-minded in the planning process. The necessity and difficulty of creating or strengthening bridges between resident social networks and the larger community effort of disaster planning and mitigation should not be underestimated (Lopez & Stack, 2001). Organizers must seek to remove barriers to inclusion of all agencies and residents if there is to be a plan that truly provides for the safety and well-being of all citizens in a community affected by disaster.

The developers of the model recommend that people be trained in its use; this may be particularly important in resource-poor communities since it assists in the development of community leaders and facilitates an increase in their understanding and ownership of the process of coproducing solutions. The concept of readiness for something is one that is shared by most cultures and the model is simple and intuitive, making it readily acceptable in most cultures. By providing training to key stakeholders in the application of the Community Readiness Model, participants' planning skills are enhanced and they are left with a tool they can use in the future as the resources and needs of the community change. Application of each element of the model is not strictly required, rather each is incorporated as the model is applied to identifying current support and building the capacity of residents to address a problem. A main benefit of the model is avoiding wasting resources on strategies for which the community is not ready and that have little chance of success. Coalitions of stakeholders can form based on a particular issue and may dissolve once addressing the issue has become an accepted part of the community's day-to-day existence. For example, the knowledge gained from experiencing the effects of previous disasters can be used to revise and improve mitigation efforts to reduce the widespread impact of a future event. In this way resources will not be wasted or underused but can instead be targeted and made available in areas that are likely to be more severely affected.

Changing the way a community responds to a disaster is neither quick nor easy. The Community Readiness Model provides both the tools and strategies that facilitate the inclusion of all voices and creates a framework for sustainability. Application of the model assists governmental entities and community leaders in bridging the interests and

concerns of all parties. Only when all segments of a community are truly represented can disaster mitigation efforts be effective.

Note

1. Information on the Community Readiness Model, including the handbook, questions addressing its six dimensions, and articles documenting its use can be obtained free of charge at the Tri-Ethnic Center for Prevention Research website: http://www.TriEthnicCenter.ColoState.edu.

References

Aboud. F., Hug, N. L., Larson, C. P., & Ottisova, L. (2010). An assessment of community readiness for HIV/AIDS preventive interventions in rural Bangladesh. *Social Science & Medicine, 70*(3), 360–367.

Brackley, M., Davila, Y., Thornton, J., Leal, C., Mudd, G., Shafer, J., Castillo, P., et al. (2003). Community readiness to prevent intimate partner violence in Bexar County, Texas. *Journal of Transcultural Nursing, 14*, 227–236.

Carlson, L. A., & Harper, K. S. (2008). Using the Community Readiness Model to guide services for LGBT Elders. *VISTAS Online*. Retrieved from http://counselingoutfitters.com/vistas/vistas08/Carlson.htm.

DiClemente, C. C., & Prochaska, J. O. (1982). Self-change and therapy change in smoking behavior: A comparison of processes of change in cessation and maintenance. *Addictive Behaviors, 7*, 133–142.

Edwards, R. W., Thurman, P. J., Plested, B., Oetting, E. R., & Swanson, L. (2000). Community readiness: Research to practice. *Journal of Community Psychology, 28*(3), 291–307.

Fellin, P. (1995). *The community and the social worker.* Itasca, IL: F. E. Peacock.

Garvin, C., & Tropman, J. E. (1998). *Social work in contemporary society.* Boston: Allyn & Bacon.

Hull, P. C., Canedo, J., Aquilera, J., Garcia, E., Lira, I., & Reyes, F. (2008). Assessing community readiness for change in the Nashville Hispanic community through participatory research. *Progress in Community Health Partnerships: Research, Education, and Action, (2)*3, 179–180.

James, S. A., Schulz, A. J., & van Olphen, J. (2001). Social capital, poverty, and community health: An exploration of linkages. In S. Sargert, J. P. Thompson, & M. Warren (Eds.) *Social capital and poor communities* (pp. 165–188). New York: Russell Sage Foundation.

Jumper-Thurman, P., Edwards, R. W., Plested, B. A., & Oetting, E. R. (2003). Honoring the differences: Using community readiness to create culturally valid community interventions. In G. Bernal, J. Trimble, K. Burlew, & F. Leong (Eds.), *Handbook of racial and ethnic minority psychology* (pp. 591–607). Thousand Oaks, CA: Sage Publications.

Jumper-Thurman, P., & Plested, B. (2000, Summer). Community Readiness: A model for healing in a rural Alaskan community. *The Family Psychologist*, 8–9.

Kennedy, S. G. B., Johnson, K., Harris, A. O., Lincoln, A., Neace, W., & Collins, D. (2004). Evaluation of HIV/AIDS prevention resources in Liberia: Strategy and implications. *AIDS Patient Care and STDs, (18)*3, 169–180.

Lopez, M. L., & Stack, C. B. (2001). Social capital and the culture of power: Lessons from the field. In S. Saegert, J. P. Thompson, & M. R. Warren (Eds.), *Social capital and poor communities* (pp. 31–59). New York: Russell Sage Foundation.

McCoy, H. V., Malow, R., Edwards, R. W., Thurland, A., & Rosenberg, R. (2007). A strategy for improving community effectiveness of HIV/AIDS intervention design: The Community Readiness Model in the Caribbean. *Substance Use & Misuse, 42*(10), 1579–1592.

Ogilvie, K. A., Moore, R. S., Ogilvie, D. C., Johnson, K. W., Collins, D. A., & Shambien, S. R. (2008). Changing community readiness to prevent the abuse of inhalants and other harmful legal products in Alaska. *Journal of Community Health, 33*(4), 248–258.

Peercy, M., Gray, J., Thurman, P. J., & Plested, B. (2010). Community Readiness: An effective model for tribal engagement in prevention of cardiovascular disease. *Family & Community Health, 33*(4), 238–247.

Plested, B. A., Edwards, R. W., & Jumper-Thurman, P. (2004). *Community readiness handbook: Advancing HIV/AIDS prevention in native communities.* Ft. Collins, CO: Tri-Ethnic Center for Prevention Research.

Plested, B., Smitham, D. M., Jumper-Thurman, P., Oetting, E. R., & Edwards, R. W. (1999). Readiness for drug use prevention in rural minority communities. *Substance Use & Misuse, 34*(4&5), 521–544.

Prochaska, J. O., & DiClemente, C. C. (1983). Stages and processes of self-change in smoking: Toward an integrative model of change. *Journal of Consulting and Clinical Psychology, 5,* 390–395.

Prochaska, J. O., DiClemente, C. C., & Norcross, J. C. (1992). In search of how people change: Applications of addictive behaviors. *American Psychologist, 47*(9), 1102–1114.

Putnam, R. D., & Feldstein, L. M. (2003). *Better together: Restoring the American community.* New York: Simon & Schuster.

Rothman, J. (2008). Multi modes of community intervention. In J. Rothman, J. L. Erlich, & J. E. Tropman (Eds.), *Strategies of community intervention* (pp. 141–170). Peosta, IA: eddie bowers publishing company.

Sampson, R. J. (2008). What community supplies. In J. DeFilippis & S. Saegert (Eds.), *The community development reader* (pp. 168–173). New York: Routledge.

Scherer, J. A., Ferreira-Pinto, J. B., Ramos, R. L., & Homedes, N. (2001). Measuring readiness for change in two northern border Mexican communities. *Journal of Border Health, 6*(1), 22–30.

Shaumik, S. (2005, January 20). Tsunami folklore "saved islanders." BBC News. Retrieved from http://news.bbc.co.uk/2/hi/south_asia/4181855.stm.

Stall, S., & Stoecker, R. (2008). Community organizing or organizing community? In J. DeFilippis & S. Saegert (Eds.), *The community development reader* (pp. 241–248). New York: Routledge.

Traynor, B. (2008). Community building: Limitations and promise. In J. DeFilippis & S. Saegert (Eds.), *The community development reader* (pp. 214–224). New York: Routledge.

Viste, J. (2007). Communicating (birth defects) prevention information to a Hmong population in Wisconsin: A study of cultural relevance. *Substance Use & Misuse, 42*(4), 753–774.

Waga, G., & Roberts, G. (2009). Assessing Community Readiness for obesity prevention in youths in the OPIC Project in Fiji: An application of the Community Readiness Model. National Health Systems Research Workshop: Program and Abstracts. *Pacific Health Dialogue, 15*(2), 104–105.

Warren, M. (2008). A theology of organizing: From Alinsky to the modern IAF. In J. DeFilippis & S. Saegert (Eds.), *The community development reader* (pp. 195–203). New York: Routledge.

And the Winds Came

Tornado Disaster Recovery in Rural Wyoming

Susan Markus

By definition, rural areas pose significant barriers to timely disaster response and organizing due to their relative isolation and sparse population. This chapter describes how the Community Readiness Model has been used in a federally funded crisis counseling program following a natural disaster in a small mining community in Wyoming. As a method of identifying, assessing, and mobilizing capacity and available resources the Community Readiness Model focuses attention on a single issue, in this case response to an unanticipated extreme event, thereby providing practitioners with needed strategies to organize an effective response.

The Wright Tornado: A Case Example

The specifics of the tornado that swept through the small rural town of Wright are described below and serve as an illustration of the application of the Community Readiness Model.

CASE STUDY

On August 12, 2005, at 4:44 P.M., the rural town of Wright, Wyoming, was forever changed by a tornado that suddenly appeared from behind a prairie hill and roared into town. Homes were destroyed, two residents lost their lives, and numerous others were injured. Residents had five minutes to seek shelter from the raging F3 tornado. Children who were outside playing did not have time to get to their own homes and instead rode out the tornado in the homes of other residents. Other Wright residents watched in horror as homes were destroyed with their family members inside them.

Wright, Wyoming, is a mining town of under fifteen hundred residents. The nearest larger city, Gillette, is thirty-nine miles north of Wright. Both Wright and Gillette are in Campbell County, and the entirety of Campbell County was declared a disaster area by President Bush on August 22, 2005. A federally funded Crisis Counseling and Training Assistance Program (CCP) grant guided the psychosocial recovery of the community, with the Community Readiness Model serving as the vehicle for the process.

Overview of the Federal Emergency Management Agency CCP

The Federal Emergency Management Agency (FEMA) provides grant funding to communities that experience a disaster to supplement mental health services provided by state and local mental health agencies. The CCP is a joint program between FEMA and the Substance Abuse and Mental Health Services Administration (SAMHSA). FEMA provides funding and administrative oversight, and SAMHSA provides technical assistance and project direction. The CCP was authorized by the U.S. Congress under the Disaster Relief Act of 1974 and later modified by the Robert T. Stafford Disaster Relief and Emergency Assistance Act of 1988 (FEMA, 2010).

According to the U.S. Department of Health and Human Services (DHHS), the mission of the CCP is to provide community-based outreach and psychoeducational services to assist people and communities in recovering from disasters (DHHS, 2009). States, U.S. territories, and tribes are eligible to apply for the grant funds, and services are structured through contractual agreements with state departments of mental health, which, in turn, often contract with communities to provide the local services (DHHS, 2009). Community services are provided by an array of trained professional and paraprofessional mental health providers, often social workers, who are indigenous to the community

affected by the disaster and who may have been affected by the disaster themselves (DHHS, 2009; Rosen, Green, Young, & Norris, 2010).

SOCIAL NETWORKING IN THE CCP

A focus on social networking is a key in promoting community resiliency and recovery throughout the CCP. In the early stages of the CCP, the goals of the program are to reach large numbers of people affected by the disaster through outreach in homes, shelters, and other community locations to assess their needs, provide emotional support and education, and make available connection to family and community support systems (DHHS, 2009). In later stages, the CCP enhances the development of a local network of partnerships and linkages, building on community strengths to develop a permanent legacy of enhanced community support systems (DHHS, 2009). The CCP does not entail the provision of clinical therapy services in traditional clinical settings.

THE ROLES OF SOCIAL WORKERS IN THE CCP

Throughout the CCP, from the federal level to the community level, social workers play a vital networking role. A key task of all social workers in the CCP involves facilitating collaboration among and between federal, state, and local disaster recovery assistance infrastructures to ensure the effective and efficient flow of information and resources at all levels of the program. Thus, strong skills in relational organizing and facilitation are necessary for social workers in all realms of the CCP.

At the federal level, social workers provide support and education, facilitating necessary networking between state, federal, and local individuals and agencies in order to complete the grant application process in emergency situations within an extremely limited amount of time. Federal program officers, usually social workers, provide connection for state and local social workers to resources for community training in disaster mental health, and ongoing technical assistance and oversight regarding federal grant program requirements.

At the state level, the roles of social worker involve facilitating cooperation and collaboration between federal, state, and local agencies and individuals that provide help and comfort to community citizens, such as FEMA, SAMHSA, the state Office of Homeland Security, the state mental health agency, and local resources such as community mental health centers, schools, faith-based organizations, law enforcement, social services, city council, and humanitarian efforts. Building on local social capital, the state-level social worker recruits, educates, trains, and empowers the development of a local, collaborative CCP community team that consists of professionals and paraprofessionals who are

indigenous to the community. Here, skills in strengths-based facilitation and community empowerment are highly important, since community ownership of their recovery efforts, relying on existing community resources and local cultural and social capital, increase community cohesion and healing and reduce the sense of vulnerability among citizens. Exertion of too much outside agency control tends to increase a sense of vulnerability among community citizens, so social workers in the CCP need skills in balancing community empowerment with ensuring that state and federal requirements and regulations are met (Baker, Hunt, & Rittenburg, 2007).

Professional social workers and paraprofessionals in local CCP programs are often community members who have been affected by the disaster. The work of the local CCP director and outreach workers includes engaging in outreach to assess the emotional needs of survivors and providing referrals when necessary, providing education regarding common reactions to disaster, facilitating connections of survivors to family and community support networks, and developing collaborative partnerships among and between individuals, families, and community organizations. Local social workers involved in the CCP also engage in outreach through various media channels and social marketing strategies to increase community awareness of the available counseling services, as well as to enhance communication and community networking.

All the people who make up the CCP disaster recovery team, from the federal to the local levels, work in concert to strengthen the existing community network of comfort and support. The goal is to arrive at a new, postdisaster normal, consisting of improved coping skills, enhanced community linkages, and increased readiness for disasters.

CULTURAL RESPONSIVENESS IN THE CCP

In alignment with providing services that are congruent with the community's needs, the CCP strives to provide culturally and linguistically competent crisis counseling services (DHHS, 2009). SAMHSA (DHHS, 2003) provides guidance for developing cultural competency in disaster mental health services along a continuum of cultural competency that was developed by Cross, Bazron, Dennis, and Isaacs (1989). The continuum consists of cultural destructiveness, cultural incapacity, cultural blindness, cultural precompetence, cultural competence, and cultural proficiency (Cross et al., 1989). The CCP requires an assessment of needs and resources and a plan for reaching the community's most vulnerable populations, such as the elderly, disabled, those living in poverty, marginalized people of color or who speak a language other than that of the dominant culture, and children. Norris, Hamblen, and

Rosen (2009) found that people who received assistance through federally funded crisis counseling projects following Hurricane Katrina favorably rated the services in the realms of respect and cultural competency. This satisfaction may be related to the strong focus on grassroots community empowerment that runs through the CCP, enhancing the likelihood that the needs of all citizens are represented through community networking. In addition, the CCP provides free outreach and counseling services in the community, removing economic and transportation barriers to accessing crisis counseling assistance by providing these services in homes and local shelters. The CCP focus on recruiting indigenous community members as counselors, and using normalizing and nonpathologizing language may also help make mental health services more consistent with cultural help-seeking norms (Norris & Alegria, 2005, p. 138).

The Community Readiness Model in the Wright, Wyoming, CCP

Bourassa (2009) promotes a culturally competent, community development approach to disaster mental health that discourages the pathologizing of individual reactions to disaster. Bourassa (2009) explains that the "core objective of social work is to advocate for social justice and the social inclusion of all marginalized populations. Therefore, with the employment of anti-oppressive practices, communities will be assured a voice and ownership over any community-driven initiatives. Facilitating communities to become active partners in the reconstruction process will increase their sense of agency and well-being" (p. 752). This focus on empowering culturally competent, community-driven initiatives is at the core of the CCP. The Community Readiness Model, developed by the Tri-Ethnic Center for Prevention Research at Colorado State University, is therefore an excellent fit as a tool for mobilizing community-based CCP efforts.

The Community Readiness Model provides an issue-specific, culturally congruent road map for facilitating community change, honoring the community's level of readiness for change, and facilitating networking to mobilize the social change process, with community members serving as experts about what is happening in their own community, as well as resources for addressing the issue at hand (Plested, Edwards, & Jumper-Thurman, 2006). This focus on community members as experts and resources is related to the theme of cultural and social capital from a strengths-based, rather than deficiency-focused, approach found in Critical Race Theory in the field of social justice. Yosso (2005) "conceptualizes community cultural wealth as a critical race theory (CRT) challenge to traditional interpretations of cultural capital. CRT shifts . . .

away from a deficit view of communities . . . and instead focuses on and learns from the array of cultural knowledge, skills, abilities and contacts possessed by socially marginalized groups that often go unrecognized and unacknowledged" (p. 69). Likewise, the Community Readiness Model recognizes and acknowledges the social and cultural capital of the community as resources for creating sustainable social change.

The Wyoming Mental Health Division had contracted with the Tri-Ethnic Center to conduct Community Readiness assessments across Wyoming in 1999 for methamphetamine prevention and conducted an assessment again in 2004 in collaboration with the Western Interstate Commission for Higher Education Mental Health to measure statewide readiness to implement a children's mental health System of Care. When the Mental Health Division began organizing the Wright, Wyoming, CCP Tornado Recovery Project, the Community Readiness Model seemed to be a natural fit for implementing the program in alignment with federal guidance for the CCP. In a rural frontier community, in which rugged individualism is valued, it was very important to honor the community's wishes for independence in designing their CCP. The Community Readiness Model guides communities through nine stages of change, beginning with the first stage of No Awareness and moving to the ninth stage, a High Level of Community Ownership, as shown in table 4.1 (Plested et al., 2006).

Because of the need for a swift response in development of the CCP plans, there was not time to conduct a community readiness assessment prior to beginning the work of the Wright Tornado Recovery Project. Nevertheless, familiarity with the Community Readiness Model from recent projects allowed for implementation of the model to guide the work. Through a social networking process, the state mental health agency was guided by the SAMHSA CCP project officer to contact a local community leader in Wright who had already begun disaster recovery mobilization. This citizen, already a local leader, became the contact for initializing crisis counseling responses in Wright, as well as the local co–project director of the CCP in Wright. Building on social networks in the community, this community leader facilitated the development of the Wright Tornado Recovery Project Outreach Team.

Although the citizens who had been contacted through social networking to become part of the Wright Tornado Recovery Project Outreach Team were estimated to be in the Preplanning Stage of readiness, most community citizens were also anticipated to be unaware of the CCP as a resource to the community. In addition, the community had never experienced a disaster before. Thus, outreach organizing plans were based on the stage of No Awareness.

Plested et al. (2006) suggest that at the No Awareness stage, the goal is to raise awareness through one-on-one visits with community members and leaders, visits with existing and established small groups, and

TABLE 4.1
Stages of community readiness

Stage of readiness	Description
1. No Awareness	Issue is not generally recognized by the community or leaders as a problem (or it may truly not be an issue)
2. Denial /Resistance	At least some community members recognize that it is a concern, but there is little recognition that it might be occurring locally
3. Vague Awareness	Most feel that there is a local concern, but there is no immediate motivation to do anything about it
4. Preplanning	There is clear recognition that something must be done, and there may even be a group addressing it; however, efforts are not focused or detailed
5. Preparation	Active leaders begin planning in earnest; community offers modest support of efforts
6. Initiation	Enough information is available to justify efforts; activities are under way
7. Stabilization	Activities are supported by administrators or community decision makers; staff are trained and experienced
8. Confirmation/Expansion	Efforts are in place; community members feel comfortable using services, and they support expansions; local data are regularly obtained
9. High Level of Community Ownership	Detailed and sophisticated knowledge exists about prevalence, causes, and consequences; effective evaluation guides new directions; model is applied to other issues

Note. From Plested et al., 2006, p. 9.

one-on-one phone calls. The No Awareness stage strategies guided the early phases of the CCP outreach work and fit well with the SAMHSA project officer's guidance to begin outreach efforts with relational social networking: door-to-door canvassing and one-on-one home visits to inform citizens of the initiative and to offer information about the assistance offered through the program. Following the door-to-door outreach, presentations were made to schools and churches and other existing community groups to inform the community of the availability of crisis counseling assistance.

Mobilizing efforts in Wright in alignment with the No Awareness stage of readiness seemed to effectively and efficiently accomplish the early goals of the CCP, those of heightening awareness of the available

assistance and increasing community knowledge about disasters to normalize reactions. With the structural guidance of the CCP and the Community Readiness Model strategies as a parallel road map for achieving the goals of the CCP, the community moved quickly through the stages of readiness. They received cultural competency training and training on the phases of disaster recovery, as in the Stabilization stage, and were able to use social networks to connect with and provide outreach services to vulnerable populations in the community, including Spanish-speaking community members, the elderly, people with disabilities, those living in poverty, and children and youth. Meanwhile, efforts moved from individual social networking to facilitation of networks among community agencies and organizations that serve individuals and families. The CCP required regular evaluation and reporting, so data were obtained and reported, as in the Confirmation/Expansion stage.

The Wright Tornado Recovery Project completed its work with the CCP approximately one year after the tornado. The community demonstrated characteristics of being at a stage of a High Level of Community Ownership with regard to the issue of disaster recovery after having engaged with the CCP. Indeed, new community linkages have been developed, and the community has detailed knowledge of disaster recovery. Before the Wright tornado, the state of Wyoming had never received a CCP grant. Now that the state government and the community have engaged in the entire process of application, implementation, and evaluation of the CCP, Wyoming has a crisis counseling template for how to respond and proceed in the event of another disaster. The networking that took place among and between state agencies built new bridges that will be in place for future disaster preparedness as well as for other initiatives in Wyoming. The Wyoming Mental Health Division now has a FEMA/SAMHSA-trained disaster response consultant on staff.

In addition, members of the Wright Tornado Recovery Project Outreach Team attended SAMHSA's "Spirit of Recovery" disaster recovery summit in New Orleans in the summer of 2006, where they learned about federal directions in disaster preparedness following Hurricanes Katrina and Rita. These community members will also be able to share their expertise from the Wright Tornado Recovery Project and their "Spirit of Recovery" experience in Wyoming to increase Wyoming's disaster preparedness, as well as to assist rural communities in other states with regard to disaster recovery. Increasing cultural and linguistic competency in the rural frontier culture of Wyoming is an ongoing process, and the Wright Tornado Recovery Project provided many opportunities to enhance cultural competency across the state.

Baker et al. (2007) conducted a qualitative study with members of the Wright community in the year following the tornado to explore vulnerability as a shared community experience. The findings of this study indicate that vulnerability can be experienced as "a shared social process, and that individuals and groups actively work to move themselves out of vulnerable states" (p. 6). They found that

> responses to the disaster resulted in changes to community procedures, to community infrastructure, and to community values . . . *together*, the residents of Wright had experienced devastation—loss of human lives and loss of homes and valued possessions—and *together* they are moving to a new normal. The process of recovering from the tornado heightened all members' awareness of their intrinsic connections to other members of the community. The common memories and the shared experience of recovering from the storm provided a focal point around which Wright residents constructed a new sense of community identity. (p. 16)

The Community Readiness Model seems to have provided a vehicle for assisting the community in this process, largely through facilitating a local, grassroots CCP that enhanced shared social processes and social networks.

References

Baker, S. M., Hunt, D. M., & Rittenburg, T. L. (2007). Consumer vulnerability as a shared experience: Tornado recovery process in Wright, Wyoming. *Journal of Public Policy & Marketing, 26*(1), 6–19.

Bourassa, J. (2009). Psychosocial interventions and mass populations: A social work perspective. *International Social Work, 52*(6), 743–755.

Cross, T. L., Bazron, B. J., Dennis, K. W., & Isaacs, M. R. (1989). *Towards a culturally competent system of care: A monograph on effective services for minority children who are severely emotionally disturbed.* Washington, DC: Georgetown University, Child Development Center.

Federal Emergency Management Agency. (2010, August 12). *Crisis counseling assistance and training program.* Retrieved from http://www.fema.gov/assistance/process/additional.shtm.

Norris, F. H., & Alegria, M. (2005). Mental health care for ethnic minority individuals and communities in the aftermath of disasters and mass violence. *CNS Spectrums, 10*, 132–140.

Norris, F. H., Hamblen, J. L., & Rosen, C. S. (2009). Service characteristics and counseling outcomes: Lessons from a cross-site evaluation of crisis counseling after Hurricanes Katrina, Rita and Wilma. *Administration and Policy in Mental Health and Mental Health Services Research, 36*, 176–185.

Plested, B. A., Edwards, R. W., & Jumper-Thurman, P. (2006). *Community readiness: A handbook for successful change.* Fort Collins, CO: Tri-Ethnic Center for Prevention Research.

Rosen, C. S., Green, C. J., Young, H. E., & Norris, F. H. (2010). Tailoring disaster mental health services to diverse needs: An analysis of 36 crisis counseling projects. *Health & Social Work, 35*(3), 211–220.

U.S. Department of Health and Human Services. (2003). *Developing cultural competence in disaster mental health programs: Guiding principles and recommendations* (DHHS Publication No. SMA 3828). Rockville, MD: Center for Mental Health Services, Substance Abuse and Mental Health Services Administration.

U.S. Department of Health and Human Services. (2009). *Crisis counseling assistance and training program* (DHHS Publication No. SMA 09–4373). Rockville, MD: Center for Mental Health Services, Substance Abuse and Mental Health Services Administration.

Yosso, T. J. (2005). Whose culture has capital? A critical race theory discussion of community cultural wealth. *Race Ethnicity and Education, 8*(1), 69–91.

Hurricane Evacuation among Mobile Home Residents in Florida

The Complex Role of Social Networks

Margarethe Kusenbach and Carylanna Taylor

The important roles and functions that social networks have in daily life are supported by a well-established body of research, too large and diverse to do justice to in passing. During natural disasters and in their aftermath, network relationships, and the many resources they offer, can make the difference between life and death. However, there are differences between network dynamics in nonemergency and those in emergency social contexts that deserve to be investigated thoroughly. A much smaller body of research, reviewed below, examines structures and impacts of relationship patterns during disasters. This chapter provides an in-depth investigation of the complex effects family, neighbor, and institutional social relationships have on the hurricane preparedness and evacuation of a particularly vulnerable, diverse, and understudied population: mobile home residents.

The authors thank University of South Florida (USF) undergraduate students Stephanie Antonio, Shon Atkins, Corina Farrar, Alissa Klein, Tegan Lesperance, Alexandra Okolie, Wanda Sloan, Claire Street, Lisa Vasquez, and Isabel Ziemba for their enthusiastic and skilled research assistance. We also thank Daniel Carpenter, Amanda Houlis, Arteisha Hughes, Alexis McLaughlin, Ryan Morris, Jason Simms, and Graham Tobin. Data collection was supported by the National Science Foundation grant SES-0649060, and by the USF via the 2007 Graduate Field Studies in Sustainable Communities Research program.

CASE STUDY

The following case serves as an example of these effects and relationships.

During her interview with the second author, Rosa, a twenty-four-year-old Hispanic woman with a husband and two young children, recalls the events around Hurricane Charley in August 2004. At that time, Rosa lived in a mobile home neighborhood in a rural Florida town located on the Gulf Coast. When Hurricane Charley was predicted to strike her town, she and her husband, both farm laborers, chose to stay in their mobile home with their two-year-old daughter. Rosa reports that they felt obligated to stay because their employers threatened to fire them if they did not continue to work through the storm warnings. She knew it was not a good decision, because they were the only ones who stayed behind in the neighborhood. Hurricane Charley changed directions at the last minute and Rosa's home remained intact, but they ended up having no electricity for a week. The only help during that time was a visit from a firefighter who brought water and other supplies. Rosa further justifies her admittedly bad choice by emphasizing that they did not have any family members nearby, that they had just arrived from Georgia and did not understand evacuation route and shelter information given on TV, and she also speculates that her Anglo-American neighbor withheld information from her purposefully due to "racism." Now living in a predominantly Hispanic apartment complex, Rosa and her family have since established stronger personal and institutional ties to the area and have made plans to evacuate to a friend's built home in case another hurricane threatens the area.

Although Rosa's story, like any other, is unique in its details, it illustrates a range of social network dynamics that can be observed with regularity during disasters requiring the evacuation of vulnerable populations. The purpose of this chapter is to comprehend and learn important lessons from those dynamics.

According to recent (2005–7) estimates by the American Community Survey, approximately 17.9 million people live in 8.7 million mobile homes in the United States. Mobile homes and mobile home residents can be found in every state and region of the country, but they are most concentrated in the Sun Belt. Ten percent of the nation's mobile homes (880,000) are located in Florida, and approximately 1.5 million Florida residents, roughly 1 in 12, permanently live in them. Floridian mobile home residents span a wide social diversity. They range from very poor to comfortably middle-class, from renters to homeowners, from single-parent families to seniors, from deeply rooted Floridians to recent immigrants and seasonal migrants.

Within Florida, mobile homes and mobile home communities are concentrated on the west (Gulf) coast of the peninsula, where the research for this chapter was conducted. The region including and surrounding Tampa Bay, which we call west-central Florida, is the most densely populated stretch of the Florida Gulf Coast. It is a high-risk area for hurricanes. In any given year, landfall probabilities in the coastal counties of this region are approximately 35 percent for a tropical storm and 14 percent for a hurricane of any category (United States Landfalling Hurricane Probability Project, n.d.). In 2004, the year before research for this chapter began, west-central Florida was threatened in quick succession by four hurricanes and seriously affected by three. Several more storms were predicted to make landfall in the subsequent years during which research was conducted, although none of those storms caused substantial damage. While there are Gulf regions that carry higher landfall probabilities for tropical storms and hurricanes, such as the Louisiana and Alabama Gulf Coast, the threat to the densely populated west-central Florida region is serious enough to warrant extensive preparation and protective efforts by residents and local governments alike.

In terms of loss of life, hurricane-induced flooding is much more dangerous than hurricane-related wind damage, and this is why the evacuation of coastal residents, as well as others living in designated flood zones, is the first priority before a hurricane strikes. A close second priority is the evacuation of mobile home residents, the population with the highest safety risk because of wind damage. Mobile homes are generally much less resilient in wind-event disasters than standard housing (Bolin & Stanford, 1991; Chakraborty, Tobin, & Montz, 2005; Cutter, Mitchell, & Scott, 2000). In the event of a hurricane or even a tropical storm, mandatory, and occasionally voluntary, evacuation orders are issued countywide regardless of where a mobile home is located, whether right on the water or dozens of miles inland, and regardless of the age or condition of the home. Although there is some evidence that Florida mobile homes built after stricter safety standards took effect in 1994 are safer than older ones (Simmons & Sutter, 2008), it is dangerous to assess vulnerability based solely on the age of a home because many other factors play an important role as well, such as upkeep and the surrounding environment. No matter how new or well reinforced a manufactured home may be, the only safe strategy for mobile home residents during a hurricane is to leave their home and evacuate to a safer location.

Recognizing the imperative to evacuate prompted us to focus our analysis on the complex role social network relationships play in the planning and implementation of evacuation among residents of mobile

homes. In many cases, external family relationships, neighbor networks, and institutional connections aid with evacuation, but there are situations in which social networks delay or even hinder this safest of protective strategies. Prior to analyzing our data, we briefly review the literature on disasters and social networks, and then describe our research sites and methods in detail.

Whereas this chapter focuses mainly on the hurricane risk and vulnerability of those living in mobile homes in Florida, many of its insights can be applied to other threats demanding evacuation, such as tornadoes and other high-wind events. Floods, wildfires, and other hazards pose threats to dwellers of mobile homes, apartment buildings, and single-family homes alike and may also require evacuation. Even though this chapter does not offer detailed comparisons with other vulnerable groups and with other types of disasters, it seems reasonable to assume that many of the social network dynamics described here can be found in the general population and across a large number of slow-onset hazardous events requiring evacuation. Evidence from additional interviews of migrants and immigrants living in apartments (among them Rosa), as well as our general and personal knowledge of evacuation decision making among Floridians living in urban and suburban neighborhoods, suggests that social networks dynamics are similarly diverse and complex across most social groups.

Previous Research

As mentioned, a systematic review of the extensive body of research establishing the impact of social networks on nonemergency areas of life is beyond the scope of this chapter. Previous research on migration, for instance, clearly indicates the general importance of family and personal networks in the biographies and daily lives of immigrants (Boyd, 1989; Ebaugh & Curry, 2000). The broader social network literature offers some evidence that disaster situations might inhibit the transfer of resources in social networks that are useful under other circumstances (Barnshaw & Trainor, 2007; Granovetter, 1973; Granovetter, 1983). A smaller body of work devoted to the role of social networks during disasters has produced a string of interesting findings, some of which are highlighted in this section. To our knowledge, no prior study exists that investigates this issue for mobile home residents.

General levels of hurricane evacuation readiness among coastal U.S. residents are alarmingly low: one-third of the general population living in areas threatened by hurricanes appears not to be concerned or adequately prepared to leave (Baker, 1991; Blendon, Buhr, Benson, Weldon, & Herrmann, 2007). While the number of mobile home residents

willing to evacuate seems to be slightly higher, somewhere between two-thirds and three-quarters of the mobile home population, evacuation readiness is still far too low given the high level of risk to this vulnerable group.

These studies suggest that an in-depth investigation of the differences between evacuees and nonevacuees is necessary to improve these numbers. Evacuation and nonevacuation need to be viewed as processes composed of many smaller steps and events, and social networks have an impact at all stages along the way. However, it is not simply a matter of having versus not having a supportive social network that makes a difference. Likewise, the structures and effects of social networks in everyday life do not necessarily remain the same during times of disaster. Some studies suggest ethnic and racial differences in the comfort levels that various groups exhibit with regard to asking for help, and with regard to actual help received, during nonemergency times. Interestingly, such differences seem to disappear in times of disasters. For example, Kaniasty and Norris (2000) showed that during and after Hurricane Andrew in 1992 whites, Latinos, and African-Americans were equally likely to ask for and receive help. A similar nonimpact of otherwise significant variables was also observed outside the United States. Kirschenbaum (2004) found that ethnic and educational differences did not noticeably affect disaster preparedness behaviors in Israel.

There is some evidence that social network characteristics are more important than some social structural factors even though they are clearly linked. For instance, a study by Hurlbert, Haines, and Beggs (2000; see also Hurlbert, Beggs, & Haines, 2001) indicates that social networks with certain characteristics (such as higher density, gender diversity, and family membership) facilitated higher levels of *informal support* than networks without these attributes. In our analysis, we discuss the occasional conflicts people experience between their informal, emotional needs and their physical, safety-related needs. It is very important to take into account the diversity and complexity of needs people experience in emergency situations because one set of network relationships may not be able to satisfy all of them at the same time.

A closer look at practical behaviors indicates that whereas social networks and the existence of strong communities generally have a positive effect on disaster preparedness (Comfort, Tekin, Pretto, & Kirimli, 1998; Kaniasty & Norris, 2000; Karanci, Alkan, Aksit, Sucuoglu, & Balta, 1999; Siegel, Bourque, & Shoaf, 1999; Sweet 1998), they can also act as inhibitors. For instance, family relationships can negatively affect preparedness behaviors such as stockpiling food (Kirschenbaum, 2004). Kirschenbaum (2004) concludes that there is a need to "look more

closely at the social processes involved in network building and dissemination of disaster communications that lead some people/groups to be more prepared than others" (p. 117). The negative effects of social network relationships in particular have rarely been discussed and are therefore highlighted in our analysis.

Other studies have more closely focused on evacuation and evaluated the significance of race and class differences (Elliot & Pais, 2006) as well as the impact of more contextual factors, such as families' decisions to stay together or separate (Haney, Elliot, & Fussell, 2007) or the issue of repeated evacuation orders (Dow & Cutter, 1998). Overall, while social networks have been found to be highly significant in these and many other studies, the literature also indicates a need for a deeper understanding of the complex impacts network relationships have on people's plans and actions during times of disaster.

Research Methods and Data

Research was conducted between summer 2005 and spring 2008 in four adjacent Florida counties in a total of twenty-one communities. The four counties were selected because they lead all other Florida counties in total numbers of mobile homes (between 44,000 and 68,000 each, according to current American Community Survey data). Nearly 340,000 mobile home residents—almost 2 percent of the nation's total—are estimated to permanently live in this four-county area.

Eighteen of the selected communities are mobile home parks, and four are small-town mobile home neighborhoods. Of the mobile home parks, one is a so-called migrant worker "camp" in which homes are rented to groups of immigrant farmworkers. Eight parks are age-restricted (fifty-five years of age and over) senior communities, and nine are so-called family parks with no age-related restrictions.

A research team consisting of the two authors and ten undergraduate students conducted interviews with members of fifty households. Four couples were interviewed together, resulting in a total of fifty-four study participants. The first author conducted twenty interviews, the second author five, and the remaining twenty-five interviews were done by the ten undergraduate students. Tables 5.1 and 5.2 offer an overview of some social characteristics of participating individuals and households. All participating households received a $25 gift card to a food market or other retail store as compensation. All names of parks and individuals in this chapter are pseudonyms.

Interviews lasted from twenty minutes to two hours, with an average length of approximately one hour. The interview schedule included

TABLE 5.1
Characteristics of individual mobile home participants

Gender	
Female	38
Male	16
Age	
20–39	18
40–59	10
60–79	19
80 and above	7
Race/ethnicity	
White	34
Latino	15
African-American	5
Employment	
In college	1
Part time/seasonal	4
Full time	9
Disabled/unemployed/homemaker	15
Retired	25

Note. N = 54.

open-ended questions on four topics: personal life history and background information, mobile home living in general, community issues, and disaster experience and preparation. Ten of the fifty interviews were conducted in Spanish and later translated into English. All interviews were tape-recorded and transcribed in full. We documented all interviews and visits in detailed field notes in which we included physical descriptions of homes and people, as well as recollections of all conversations and activities.

We recruited our interview participants through a variety of leads: the first author's participation in a mobile home owners' organization (Federation of Manufactured Home Owners of Florida); contacts made through service agencies; referrals by university colleagues; family, friends, and work contacts of students; referrals by previous informants; cold contacts; and chance encounters. Overall, though we did take advantage of convenient opportunities, our sampling strategy was systematic in that we included residents of all park types that exist in the region, as well as a broad diversity of informants in terms of their (adult) age, race/ethnicity, family status, household size, educational background, work status, and residency pattern. To analyze the interview data, we repeatedly read each transcript and set of field notes and

TABLE 5.2
Characteristics of participating mobile home households

Community	
Family park	20
Senior park	18
Migrant worker camp	3
Mobile home neighborhood	9
Environment	
Urban	15
Suburban	20
Rural/small town	15
Household type	
Single	15
Partner	11
Children under 18	17
Other family	2
Housemates	5
Tenure	
Homeowner	40
Renter	10

Note. N = 50.

then sorted, annotated, and analyzed significant data pieces according to the principles of grounded theory (Charmaz, 2006). Because of the exploratory nature of our research and the relatively small number of participants in this qualitative study, we do not offer frequencies or statistical analyses but focus entirely on highlighting the observed network-related patterns and effects in order to better inform future qualitative and quantitative research on this topic.

Hurricane Evacuation Supports and Obstacles

The following analysis focuses on the roles that social networks—that is, external family, neighbor, and institutional relationships—play in hurricane-related decision making in mobile home households. More specifically, we describe the positive and negative impacts of those social networks, impacts we also refer to as evacuation supports and obstacles.

THE ROLE OF FAMILY NETWORKS

In this section, we discuss the positive and negative impacts of family networks extending beyond the participating household with regard to hurricane evacuation. Clearly, the most beneficial function of having family members outside the household is their presumed willingness and ability to provide shelter for the evacuating mobile home household. However, we also observed cases in which family connections impacted evacuation planning and behaviors in a negative manner.

Staying with adult children living in site-built homes, condos, or apartments was the primary evacuation plan for over half of our informants over the age of fifty. In some cases, adult children resided nearby, whereas in other cases they lived as far away as North Carolina. Most senior evacuees planned to drive to their children's home; however, in several cases in which seniors were very frail or did not drive anymore, adult children had promised to pick up their parent(s). Even though the thought of staying with an adult child was clearly comforting to our informants, it was at times difficult for us to decide whether this was a realistic option or an unrealistic, even dangerous, wish.

Several interviewed seniors did not have any of their own children living nearby but were able to make arrangements with a niece or a nephew. More distant adult relatives were also available in some of the cases. For example in 2004, our senior informant, Josephine, and her husband, Bob, once evacuated to the home of their son's nephew, where Bob could share an oxygen tank (powered by a generator, in case this was needed) with someone else who evacuated to the same house, a person he had not known before. And Ethel, a divorced woman in her fifties, planned to drive or fly out of state to stay with her ex-husband, with whom she was on friendly terms.

Another relatively common evacuation plan for middle-aged, and occasionally senior, adults was to stay with a sibling residing in a safer location. Some participants said they would drive to a different state to stay with a brother or sister—a plan that might prove to be much more difficult than they foresee. The decision of younger adults to stay with a parent occurred but was uncommon among study participants. Amber, a young mother of a toddler, planned to rely on her new boyfriend's parents, who lived down the street from her, yet she was worried about her own mother, who lived by herself in another mobile home about an hour's drive away. Ruth, a young woman who lived with a boyfriend and their four children, mentioned the option of going to her mother's house less than a half hour away, but she explained that she "hates to ask" her mother for favors and would rely on her only as a last resort.

Several immigrant families living in a small coastal town presented another example of extended family networks being a supportive resource (Ebaugh & Curry, 2000). In addition to biological and affinal kin, extended family networks can include cultural (or "fictive") kin such as godparents and honorary aunts and uncles. We found that extended immigrant families typically did not rely on relatives to take them in during a storm because rarely did any of the relatives (if there were any) have a home safe or large enough to accommodate everyone. Instead, some pooled their resources and evacuated together to a shelter. Elena described her experience of evacuating with other relatives to the local shelter as "scary" for the adults but "fun" for the children, who got to have extended playtime with their cousins. Newer arrivals typically relied on more acclimated and experienced family members to tell them where to go and what to take along. Households with transportation problems relied on other family members to pick them up. In the case of one American-born Latina, her family met up with several other family members at a motel in the Orlando area. The family was planning to evacuate together again in the future and was adamant about not wanting to use a shelter.

We now turn to examples illustrating that external family relationships are not always a resource that is helpful for disaster preparation and evacuation. Some people who had close relatives living in nearby and safe locations did not stay with them and were not planning to do so in the future. Heather, a single mother of four children and grandmother of a toddler, told us that she did not get along with her younger brother, who lived with her stepmother, and would therefore not evacuate to the stepmother's home, which in fact was too small to accommodate all of them comfortably. However, Heather planned to leave her dogs with the stepmother on her way out of town to find a motel room as a shelter for her family, as she had done in the past. Similarly, Sue, a single woman in her seventies, decided against staying with her nearby niece because the niece had "too many pets." Sue planned to rely on finding a hotel room if she really needed to evacuate.

In addition to family conflicts or incompatibility issues, the volatility of personal relationships can also present an obstacle. At the time of Hurricane Vanessa in 2004, a young mother of a son and owner of two dogs had a safe place to go: her boyfriend's house. However, when their relationship ended suddenly, she was left with no backup plan during the three hurricanes that followed in quick succession, and she struggled significantly as a result. Vanessa ended up staying home one time, which she deeply regretted, and another time managed to find a friend who took her in. Last, some people jeopardized their safety in choosing to not rely on anybody. Bella, an independent-minded single woman in her sixties, had plenty of choices with her daughter, brother, and other

family members living nearby in site-built homes. But Bella had no plan to evacuate and insisted that she did not need any help.

In the above cases, existing family relationships did not yield a safe evacuation destination because of conflicts within families or general resistance to evacuation. We came across several additional cases in which external family relationships presented obstacles rather than help, even in the absence of conflict or resistance. It sometimes happened that all nonhousehold family members also lived in mobile housing, possibly in even more vulnerable locations. Randy, a divorced man in his sixties is a dog owner and in good health. His evacuation plan was to drive north in his van and pull his pop-up trailer behind for camping, yet he was not sure if he would actually be able to leave because of his responsibility for two older female cousins, one of them very frail, who lived in separate homes in the same park. Another informant, Liz, was responsible for her single adult son, a sufferer from bipolar disorder living in a mobile home right next to hers. Liz and Randy represent the small number of mobile home residents whose relatives beyond their own household presented a "burden" rather than a resource in planning and implementing their own evacuation.

Furthermore, there were cases in which respondents simply did not have family members living close enough to offer shelter, or willing and able to help in other ways from a distance. This situation applied to all migrant workers as well as to some other recent arrivals to Florida. And last, there were a handful of individuals, middle-aged and senior, who simply did not have any family members apart from the ones they lived with, or who had none at all.

Overall, family members were a comforting and safe resource, but there were a number of exceptions, namely situations in which family networks did not offer help with evacuation and even presented additional obstacles. The described family networks and resulting evacuation decisions appear to be most strongly shaped by age, gender, class, and (im)migration. Since these family networks are not unique to mobile home residents, we can assume that family-oriented evacuation patterns play out similarly in the general population, while keeping in mind that only geographically vulnerable groups among the conventionally housed are asked to evacuate.

THE ROLE OF NEIGHBORS

In many situations, neighbors are an excellent source of assistance and support (Kusenbach, 2006). Our interviews were rife with examples of neighborly help and assistance. Neighbor relations, as one form of "weak ties" (Granovetter, 1973; Granovetter, 1983), are exceptional

resources since they may diffuse information leading to new opportunities and the building of community. In a similar manner, Barnshaw and Trainor (2007) emphasize the strength of large, extended (as opposed to small and concentrated) networks, but they also note that disaster contexts might inhibit the activation of some of these ties, thereby undermining the transfer of social resources.

The structural problem with neighbor relationships for the purpose of hurricane evacuation from mobile home parks and neighborhoods is that these contacts cannot provide immediate relief because neighbors' homes are typically just as unsafe as one's own residence. This weakness is clearly linked to mobile home communities and other geographically risky areas (such as waterfront neighborhoods), and it therefore does not affect the general population to the same degree. However, like dwellers of conventional homes and apartments, mobile home residents are sometimes able to benefit from a neighbor's network contacts beyond the immediate community that may include family members, friends, or institutional relationships. In this section, we focus on several cases of neighbors leading to evacuation solutions, however, we begin with the questionable practice of mobile home residents sharing their own place of living with neighbors in the hope of increasing their comfort and safety.

In several cases, neighbors evacuated to another mobile home in their community based on the belief that it was safer than their own. Unfortunately, weathering a hurricane anywhere in a mobile home community is not at all safe. Even though an individual home might appear to be as, or even more, resistant as a site-built home, the risk of being hit by debris from other mobile homes disintegrating in a storm is much too great. For instance, Betty, a blind woman in her forties living by herself, evacuated to the nearby mobile home of her friend Liz, a former nurse, during several of the 2004 hurricanes. Although this choice might have been psychologically comforting for Betty, she was taking a high risk in terms of her physical safety.

A second example is Sue, also a retired nurse, who opened her mobile home to several park neighbors during a hurricane, including a woman who depended on oxygen. Sue's home had a site-built addition, an extra room that she and others considered to be reasonably safe. However, had there been a direct hit, this belief might have turned into a fatal misperception. In sum, some mobile home residents, especially very caring ones, opened their own homes to neighbors in need. Yet, in the worst case, such action might actually increase the vulnerability of the entire group. Here and elsewhere we see that a person's emotional needs can be in conflict with his or her physical needs in an emergency. This conflict is very difficult to reconcile. Social network relationships are often able to satisfy either need but not always at the same time.

Notwithstanding these cases of neighborly assistance with potentially dangerous outcomes, relationships with neighbors can be very positive in leading to safe evacuation. For instance, Joanne and Paul, a couple in their eighties, reported evacuating to a vacant home owned by the neighbor of their neighbor's son, Edgar. This caring homeowner had made his entire home available to help out Edgar's elderly parents and their friends. In two senior parks, residents discussed the need to collectively organize the evacuation of vulnerable members. For example, Joanne and Paul mentioned that "there are a lot of little old widowed ladies that just can't get out" living in their community. They reported talking with other members of the homeowners' organization about taking these neighbors to shelters, but they had not yet planned any specific steps.

In only one case did we come across a group of neighbors that had prearranged their evacuation. Anita and Thelma, two elderly sisters living in separate homes in a senior park, were part of a group of dog-owning residents that had found a collective solution. Together with about five other park residents, they always evacuated to a "little chapel" near their home that is owned by the Catholic Church. Even though the chapel was not an official shelter, they had permission to use it, and they were even allowed to bring along their dogs. In this last case, an institutional connection was combined with a neighborhood network to arrange for the (presumably) safe evacuation of mobile home residents who owned pets and were thus particularly at risk of not evacuating otherwise. As an aside, the considerable reluctance of pet owners to evacuate that we observed among mobile home residents appears to be a serious problem also among other vulnerable groups.

THE ROLES OF INSTITUTIONAL RELATIONSHIPS

The larger community is an important factor influencing the role of networks in planning for evacuation (Beggs, Haines, & Hurlbert, 1996; Dynes, 2005). While community networks were not the focus of our study, in several cases we were able to document the usefulness of social ties beyond family and neighbor relationships, for instance those made in institutional contexts such as work and church. Again, such links can be presumed to be similar among conventionally housed groups. We first discuss several examples in which work relationships appear crucial in planning for evacuation.

Estella, for example, reported evacuating repeatedly with her husband and their six children to an empty unit at the nearby apartment complex where her husband was an assistant manager. Another informant, Phyllis, a widowed woman in her sixties with a full-time job at a local car auction, had a friend from work who had offered to take her

in during a hurricane, including Phyllis's cat and her roommate, John, a single Vietnam Veteran in his sixties with (according to Phyllis) no family members or friends.

The most poignant, and at the same time troubling, example of the importance of work relationships was presented by the migrant workers who shared homes in the so-called mobile home camp. Because of their social isolation resulting from migration and work patterns, the vast majority of these workers had no family, neighbors, or friends who could offer a safe place for evacuation, and they were reluctant to use public shelters. Most workers we interviewed seemed fearful of having any contact with officials or authorities due to their lack of "papers." The migrant workers in our sample had invested all their hope for help in their "boss," who in many cases was also their landlord and the person providing all transportation. Sometimes the employer was simply the only person they knew aside from coworkers. Only Alvaro had stayed at his employer's home during a hurricane together with a group of coworkers, and none of the other migrant workers participating in our study knew for sure that their employers would help out. For instance, Miguel, a young man with a family in Mexico, speculated that "if we work for them, I'm pretty sure that they would help, probably." Beyond this hope, Miguel did not have any plans of how to prepare for a hurricane, or where to go.

Another example of an institution-based social connection making a difference in evacuation planning is the case of Joanne and Paul, an elderly couple: they once evacuated to the safe home of a younger couple whom they knew from the church they were involved with back in Missouri. In several other cases, seniors were able to rely on social connections made at their church with people outside their neighborhood who ended up offering safe evacuation destinations. Generally speaking, next to family and neighbor networks, churches (current and former) appear to be the most beneficial institutional resource for seniors, while work connections provided the most beneficial outcomes for younger and middle-aged adults.

EVACUATION INDEPENDENT OF NETWORK RELATIONSHIPS

About one-fourth of our participants did not rely on social networks for evacuation and instead turned to the state (meaning public shelters) or the tourism industry (meaning hotels) for solutions. There appear to be three reasons for this choice, all mentioned in passing above: first, social networks may exist but not provide needed resources; second, they may exist but be nonpreferred options (this could also be called nonactivation); and third, they may not exist. As a last step in our analysis, we briefly discuss the use of public shelters and hotels as evacuation destinations and their links with network relationships.

It was disheartening to learn that many informants did not consider evacuation at public shelters, even if this seemed to be the only safe and reliable place available in their cases. Aside from several Latino families and family networks that evacuated together to public shelters, only a small number of non-Hispanic seniors, and even fewer non-Hispanic families, even considered shelter evacuation. Many informants explicitly ruled out the idea of going to a shelter. Based on sensational media reports and hearsay, they often had incorrect perceptions of what shelter evacuation would be like—believing, for example, that shelters were dangerous and crime-ridden places. Although it is true that the conveniences of shelter evacuation are very limited, such perceptions do not seem to be warranted. None of the people in our sample who actually evacuated to a shelter complained about the conditions. To the contrary, some described the shelter evacuation as a positive experience. Loretta, a Latina living in an impoverished neighborhood who evacuated with her husband and their three children to a shelter on the attractive campus of a nearby private college, was enthusiastic about the shelter and the many services it provided, including meals and entertainment for the children. In fact, unlike many participants who decided to stay home or rely on the help of family members or friends, informants who opted to use shelters did not express regret for their choice of evacuation destination. We mentioned above that in some cases shelter evacuation was positively tied to social network relationships. It also happened that a onetime positive experience at a shelter fostered new social ties that were then relied upon during subsequent hazardous events. In sum, shelter evacuation can, strictly speaking, function entirely independent of social relationships, but in reality it is often tied to the experiences and plans of other people within one's social network.

Much more frequent than staying at a shelter was an evacuation plan that one informant best described as "load up and go." Many participants described a version of "driving north" as their primary evacuation plan. Keep in mind that driving north might end up being a strenuous, expensive, and—most important—unsafe plan of action. Some informants told us that they were planning to drive to places as far as Georgia, Alabama, North Carolina, and even New York to reach the homes of relatives or friends. But there were many others who did not have a network-based destination and simply hoped to find a hotel or motel room somewhere far enough away from the danger. In some cases, what spurred this latter choice was the absence of network-based alternatives (combined with a nonconsideration of shelter evacuation); at least equally often, however, it was rooted in the preference of informants to not rely on existing network relationships that appeared to be helpful (nonactivation). It is quite difficult to clearly differentiate

between these two circumstances, and to specify the exact conditions under which driving north becomes viewed as the best available evacuation strategy. Load up and go–type evacuees included not only adult couples and singles but also a surprisingly high number of frail seniors and families with small children, as well as many pet owners, such as a household with over a dozen cats.

It is quite possible that the mentality of load up and go is rooted in the mobility and instability many participating households presently experience or have experienced in the past, whether voluntary, as in the case of former snowbirds who eventually settled down in Florida, or involuntary, as in the case of some young families and migrant workers. Undoubtedly, load up and go–type evacuation plans can also be found in the general population, yet possibly to a lesser degree, and such plans likely become less risky with increasing material resources at hand. What is certain is that the absence of resourceful relationships, or the unwillingness to burden, or compromise with, others within one's network, rarely motivated mobile home residents to evacuate to a shelter. Rather, it resulted in choosing an alternative that was far more uncertain, very likely less safe, and officially discouraged.

Conclusion and Recommendations

In this chapter, we argued that the value of social network relationships providing or leading to safe accommodation during an emergency cannot be overstated. We discussed many instances in which family, neighbor, and institutional relationships provided resources that could have made the difference between life and death if the worst-case scenario had occurred. Yet we also discussed many examples of situations in which social network relationships did not automatically lead to safety; in some cases they even presented additional barriers. Further, we hinted at the troubling fact that many potentially unsafe evacuation behaviors are rooted in the nonactivation of network relationships that could potentially lead to safety. The safest alternative to network-based evacuations, public shelters, is generally less preferred than individualistic and market-based strategies, however unsafe or strenuous these options may actually be. Last, while we found that social network relationships are excellent resources for meeting both the *emotional* and *physical* needs of people threatened by disasters, we also found that the necessities of comfort and safety may pull people in different directions. Social networks may not always be able to satisfy both needs at the same time.

We now briefly comment on two other findings from our research that we were not able to discuss in sufficient detail: the impact of social networks on risk perception, as one of the most important steps leading

to evacuation, and the role of relationships within the household. Both findings echo the complex functions and outcome of social networks that we were able to establish here. First, while social networks may positively impact risk perception, for instance through sharing warnings and information such as evacuation orders, they are not an automatic source of reliable information and under certain circumstances even reinforce potentially dangerous misperceptions. For example, the false belief that evacuation shelters and disaster-relief units request immigration papers persists in some networks of undocumented workers, keeping them from seeking government assistance.

Second, we observed the following with regard to household members. The safety—and potentially the survival—of all household members usually depends on the arrangements made for the weakest family member. Specifically, we observed in some cases that entire households were put at risk because of concerns over, and lack of arrangements for, pets. In other cases, such as families with members that have serious health problems or special needs, a choice was made to "sacrifice" the well-being of the weakest family member to benefit the comfort and safety of the majority. Both scenarios are undesirable and could likely be improved through the activation of external family, neighbor, and institutional relationships.

In closing, our analysis of evacuation supports and obstacles highlights both the importance and complexity of network relationships among mobile home residents. This chapter offers a point of departure for reconsidering evacuation policy and services, such as strengthening relationships at the community level by activating work and church networks, and reshaping perceptions of shelter evacuations to discourage nonevacuation or the similarly risky load up and go strategy. To better address social network relationships that present obstacles to evacuation for mobile home residents and conventionally housed people alike, we need to more systematically investigate the factors and dynamics that lead to the activation or nonactivation of social ties in emergency situations. Overall, we hope that further research on these topics will be able to use and reevaluate the findings offered in this chapter.

We conclude with a list of ten practical recommendations resulting from our research that address an array of strategies on a continuum of levels, beginning with state and county policies and ending with community and individual practices. Many of the following suggestions help increase the hurricane resilience of other vulnerable groups as well as the general population. Most are applicable to preparation for other hazards requiring evacuation such as wildfires or floods.

1. More education is needed regarding public shelters in order to address widely existing fears and concerns, particularly those of

undocumented immigrants who operate with the misperception that a lack of papers would mean a lack of service or, worse, deportation.

2. Positive (but realistic) media messages and campaigns about the advantages of shelter evacuation will help overcome concerns that mobile home residents share with the general population. Education materials could emphasize aspects such as services and companionship for children or the accommodation of large families and extended family networks.

3. More evacuation alternatives need to be made available to pet owners. Existing restrictions at pet shelters are understandable, but they need to be viewed in the context of saving human lives. Turning people away who have not preregistered or do not have current vaccination records is irresponsible. Some options for owners of difficult-to-accommodate or dangerous pets should exist as well.

4. Similarly, special needs shelters need to be more flexible in accommodating families and seriously consider the issue of family separation, which has entirely negative implications (Haney et al., 2007). More education and information are needed about the availability and restrictions of special needs shelters, and about alternative services that will allow families to stay together.

5. Disaster education of mobile home residents needs to better communicate the special risks they experience and warn against a false sense of safety that might lead residents to "shelter at home." Education of mobile home residents needs to underscore that the primary strategy in the case of a hurricane must be evacuation. Advertising campaigns by the manufactured home industry that undermine the perceived need to evacuate for *all* mobile home residents should be abolished. Prior research shows that public education campaigns can have positive effects on risk perception and preparation for disasters (Paton & Johnston, 2001) but shows also, unfortunately, that levels of risk perception and preparedness remain much too low (Paton, 2003).

6. Disaster education of the broader population needs to highlight that, in addition to the structural features of one's own home, an accurate risk assessment takes into account the vulnerabilities of the surrounding natural and man-made environment. In particular, those living near mobile homes should also be encouraged to evacuate.

7. Neighbor networks can provide a resource by assisting vulnerable individuals in evacuation, for instance through arranging for safe evacuation elsewhere, helping with planning and transportation,

and raising local awareness of needs. In some locations, for example in many family mobile home parks, practical and cultural barriers exist that prevent a workable collective approach. A better knowledge of these barriers is the first step toward dissolving their negative impacts.

8. Families and groups of friends should find evacuation more affordable, and potentially more enjoyable, by pooling their resources for evacuation and trying to evacuate together. It is vital to strengthen the weakest link in the network and to plan well ahead for family members with special needs.

9. Pet owners must be urged to arrange prior to hurricane season for safe evacuation of the entire household. This should be considered part of the responsibility of owning a pet. With increased time and creativity to prepare, alternative arrangements can be found in most cases, as our examples show.

10. Individuals and communities would do well to consider, and build upon, the importance of institutional ties outside the neighborhood to churches, workplaces, and schools. Other institutions might provide significant resources as well. Following the logic of the "strength of weak ties" (Granovetter, 1973; Granovetter, 1983), diversifying network relationships should increase evacuation options.

References

Baker, E. J. (1991). Hurricane evacuation behavior. *International Journal of Mass Emergencies and Disasters, 9*, 287–310.

Barnshaw, J., & Trainor, J. (2007). Race, class, and capital amidst the Hurricane Katrina diaspora. In D. L. Brunsma, D. Overfelt, & J. S. Picou (Eds.), *The sociology of Katrina: Perspectives on a modern catastrophe* (pp. 91–105). New York: Rowman & Littlefield.

Beggs, J. J., Haines, V. A., & Hurlbert, J. S. (1996). Situational contingencies surrounding the receipt of informal support. *Social Forces, 75*, 201–222.

Blendon, R. J., Buhr, T., Benson, J. M., Weldon, K. J., & Herrmann, M. J. (2007). *Hurricane readiness in high risk areas.* Harvard School of Public Health, Project on the Public and Biological Security. Retrieved July 9, 2011, from http://www.hsph.harvard.edu/news/pressreleases/files/Hurricane_2007_Survey_landing_page_overall_results.doc.

Bolin, R., & Stanford, L. (1991). Shelter, housing and recovery: A comparison of U.S. disasters. *Disasters, 15*, 24–34.

Boyd, M. (1989). Family and personal networks in international migration: Recent developments and new agendas. *International Migration Review, 23*, 638–670.

Chakraborty, J., Tobin, G. A., & Montz, B. E. (2005). Population evacuation: Assessing spatial variability in geo-physical risk and social vulnerability to natural hazards. *Natural Hazards Review, 6*, 23–33.

Charmaz, K. (2006). *Constructing grounded theory: A practical guide through qualitative analysis*. London: Sage.

Comfort, L., Tekin, A., Pretto, E., & Kirimli, B. A. D. (1998). Time, knowledge and action: The effect of trauma upon community capacity for action. *International Journal of Mass Emergencies and Disasters, 16*, 73–91.

Cutter, S. L., Mitchell, J., & Scott, M. (2000). Revealing the vulnerability of people and places: A case study of Georgetown County, South Carolina. *Annals of the Association of American Geographers, 90*, 713–737.

Dow, K., & Cutter, S. L. (1998). Crying wolf: Repeat responses to hurricane evacuation orders. *Coastal Management, 26*, 237–252.

Dynes, R. R. (2005). Community Social Capital as the Primary Basis for Resilience. Preliminary Paper #344. University of Delaware Disaster Research Center.

Ebaugh, H. R., & Curry, M. (2000). Fictive kin as social capital in new immigrant communities. *Sociological Perspectives, 43*, 189–209.

Elliot, J. R., & Pais, J. (2006). Race, class, and Hurricane Katrina: Social differences in human responses to disaster. *Social Science Research, 35*, 295–321.

Granovetter, M. (1973). The strength of weak ties. *American Journal of Sociology, 78*(6), 1360–1380.

Granovetter, M. (1983). The strength of weak ties: A network theory revisited. *Sociological Theory, 1*, 201–233.

Haney, T. J., Elliot, J. R., & Fussell, E. (2007). Families and hurricane response: Evacuation, separation, and the emotional toll of Hurricane Katrina. In D. B. Brunsma, D. Overfelt, & J. S. Picou (Eds.), *The sociology of Katrina: Perspectives on a modern catastrophe* (pp. 71–90). New York: Rowman & Littlefield.

Hurlbert, J. S., Beggs, J. J., & Haines, V. A. (2001). Social networks and social capital in extreme environments. In N. Lin, K. Cook, & R. S. Burt (Eds.), *Social capital: Theory and research* (pp. 209–231). New York: De Gruyter.

Hurlbert, J. S., Haines, V. A., & Beggs, J. J. (2000). Core networks and tie activation: What kinds of routine networks allocate resources in nonroutine situations? *American Sociological Review, 65*, 598–618.

Kaniasty, K., & Norris, F. H. (2000). Help seeking comfort and receiving social support: The role of ethnicity and context of need. *American Journal of Community Psychology, 28*, 545–581.

Karanci, A. N., Alkan, N., Aksit, B., Sucuoglu H., & Balta. E. (1999). Gender differences in psychological distress, coping, social support and related variables following the 1992 Dinar (Turkey) earthquake. *North American Journal of Psychology, 1*(2), 189–204.

Kirschenbaum, A. (2004). Generic sources of disaster communities: A social network approach. *International Journal of Sociology and Social Policy, 24*, 94–129.

Kusenbach, M. (2006). Patterns of neighboring: Practicing community in the parochial realm. *Symbolic Interaction, 29*, 270–306.

Paton, D. (2003). Disaster preparedness: A social-cognitive perspective. *Disaster Prevention and Management, 12*, 210–216.

Paton, D., & Johnston, D. (2001). Disasters and communities: Vulnerability, resilience and preparedness. *Disaster Prevention and Management, 10*, 270–277.

Siegel, J. M., Bourque, L. B., & Shoaf, K. I. (1999). Victimization after a natural disaster: Social disorganization or community cohesion? *International Journal of Mass Emergencies and Disasters, 17*, 265–294.

Simmons, K., & Sutter, D. (2008). Manufactured home building regulations and the February 2, 2007, Florida tornadoes, *Natural Hazards, 26,* 415–425.

Sweet, S. (1998). The effects of a natural disaster on social cohesion: A longitudinal study. *International Journal of Mass Emergencies and Disasters, 15,* 321–331.

United States Landfalling Hurricane Probability Project. *Tropical Meteorology Research Project.* Colorado State University and the GeoGraphics Laboratory at Bridgewater State College. Retrieved February 1, 2010, from http://www.e-transit.org/hurricane/welcome.html.

The Role of Leadership in Disaster Relief and Management

Golam M. Mathbor and Kathleen A. Kost

Disaster can occur at any time, with or without warning, and in any place. Leadership is a key component in making sense of disaster relief and management initiatives at all stages. This chapter applies the concepts of social capital and social networks to the identification and development of leadership during the 2004 tsunami in Indonesia. The issues this event raises for aid organizations are similar to those within the United States in terms of logistics; however, they can be particularly challenging in regard to location, language, and culture, as the recent earthquakes and floods in Pakistan, Haiti, and Indonesia suggest. In such international situations, staff from diverse aid organizations must work effectively with both indigenous leaders and those from multiple nongovernmental organizations (NGOs) to effectively respond to people impacted by disaster. Their efforts are often complicated by a suspicion and distrust of outsiders. They must also be able to facilitate the continuation of relief efforts to prevent the outbreak of disease and further deterioration of social conditions on the ground. Thus the invisible

Special thanks to the Munasinghe Institute for Development (MIND) for appointing Golam Mathbor as senior research fellow of MIND to conduct a research project on social capital in Sri Lanka, Maldives, and Indonesia. This chapter is based on his extensive site visits in tsunami-affected regions and interviews with key informants in these countries.

assets that work to bind the community are particularly relevant to this discussion.

Leadership in both the private and public sectors is a conduit for learning opportunities; the ability to adapt to unexpected events and to the uncertainty these events create is an essential skill if disaster relief efforts are to be successful (Chaskin, Brown, Venkatesh, & Vidal, 2001). Hence leadership must be evaluated in preparation and planning for future disasters. Past experience; the role of those involved in shaping the bureaucratic response to relief efforts, including the distribution of funds needed for an effective response; the permeability of community leadership to involve additional individuals in the process; and how the community and key individuals learn from both negative and positive events are all critical aspects in a discussion of how to improve the community's management of a disaster (Telford & Cosgrave, 2007). Chaskin et al. (2001) note that it is essential that expectations regarding roles and shared responsibilities have clarity in order for these efforts to be successful.

The role of leadership and the vision and ability of leaders to secure resources for rebuilding as well as their ability to access both visible and invisible assets such as social cohesion and social networks are essential to the success of their efforts. Likewise, the actions of government entities and the business community in relief operations and disaster management, and partnerships they may have with NGOs, impact both the scope and effectiveness of disaster relief efforts. As Telford and Cosgrave (2007) suggest, there is a need for both standards and definitions that are systemwide so that diverse organizations have a common understanding of what is needed. The 2004 tsunami destroyed or severely disrupted traditional and technological methods of communication, forcing leaders and relief workers to rely on diverse social networks to distribute needed information. Key government agencies, NGOs, schools, and religious organizations may act as powerful bridges providing information about what is needed by whom and where (Comfort, Ko, & Zagorecki, 2004).

People who have experienced a disaster firsthand or been involved in disaster management inform and legitimize any discussion on how best to manage a disaster. This is the case even if involvement was external to official action resulting from an on-the-field need to provide immediate and specific assistance. Officials exercising a leadership capacity must be well informed and function within clearly defined lines of authority. Those in the field providing primary assistance need to know not only whom to contact for allocation and resource decisions but also how best to effectively marshal available resources such as volunteers in response to an immediate need.

Sampson (2008) argues that communities provide opportunities to build social capital through the networks they generate that enhance trust and maintain social control. Communities represent complex overlapping systems of social networks among families and friends and thus create norms of behavior that are not only comprehensive but also cohesive in their ability to bind people together. These networks of families and friends in turn exert a level of social cohesion that permeates the organizations and institutions within a given community.

The historical relationship developed between communities and a government has generally assisted in mitigating the consequences of natural disasters, since these social networks extend beyond local institutions to build mutual trust and interdependence with the wider society. For example, communities in the United States and European Union have a history of reliance on the government for assistance in rebuilding after a disaster through the connections and networks local institutions have with the central government. For the most part, people have been able to trust that their governments will assist them when disasters occur.

Sri Lanka: A Case Illustration

The following provides a case illustration of the leadership challenges that organizations faced in Sri Lanka in the aftermath of the 2004 tsunami. The relationship between government agencies, nonprofits, and residents differs markedly from that in the United States.

CASE STUDY

On December 26, 2004, an earthquake in the Indian Ocean near Sumatra triggered a series of tsunamis that killed tens of thousands of people across eleven countries. The 2004 tsunami that affected Sri Lanka was a coastal phenomenon that killed nearly thirty-one thousand people (CNN, 2004). Before the tsunami, villages along the coastal road south of Colombo in western Sri Lank bustled with life. Between the villages were stretches of green and serene beach scenes.

After the tsunami, all that could be seen was destruction for miles in all directions. The rubble of bricks and concrete and wood lay where it had been tossed by the violence of the waves. Clothes and debris were snagged on trees, so high that one realized that they indicated the height the water had risen. Many people clung to these trees until they were rescued. The shattered remains of buildings were scarred by watermarks, some close to the roofline.

International relief efforts were evident in the tents, supplies, and water bowsers. Although the government was slow to move, many Sri Lankans were active in small local organizations. One such organization was SERVE; located in the Western Province, SERVE operated a small relief camp for displaced families in Moratuwa. Attempts by the executive director to collaborate with an NGO failed because the need was greater in other areas of the country. At this point the executive director wrote to friends and other NGOs, both local and foreign, to gain the resources needed to convert a house that had been used for an after-school child-care program into a shelter that would house forty-five individuals ranging from a two-week-old infant to the elderly. Although the facility was crowded, given the conditions on the ground it was more secure than tents and more easily facilitated the distribution of food and other necessities.

Co (2004) finds that communities in East Asian and Pacific regions rely on volunteer organizations for rebuilding and distrust attempts by the central government to assist them. This distrust is due primarily to their historical experiences of colonialism and oppression at the hands of the central government. Thus residents in these regions are less likely to look to the government for help and more likely to participate in and depend upon formal and informal volunteer organizations when disasters strike. Effective use of the invisible assets within these volunteer organizations is therefore crucial in disaster relief and management activity. Accessing the capacity and strengths of social networks within a community through these organizations enables cooperative action that can then generate opportunities and resources to further mitigate the effects of a disaster.

Volunteer organizations are uniquely suited to the generation of social capital and the development of trust because of the scope of the social networks participants have with others (Wollebaek & Selle, 2002). Members of these organizations are likely to have multiple associations across diverse social networks that can be activated when needed. Thus, through the social networks of these individuals, in the form of their collective social capital, resources can be accessed for communication, education, and delivery of support and services during a disaster and its recovery. For, once the immediate needs of residents are addressed, the effects of the disaster on technological needs will be felt. By accessing the social networks of members of volunteer organizations, resources such as generators, water-purification equipment, and all-terrain vehicles can be found and made use of.

Invisible assets affect a community's preparedness for a disaster and the mechanisms and processes it uses in rebuilding. Strong social cohesion orchestrated through use of these invisible assets accelerates a

community's rebuilding in disaster-affected areas. Leadership is a key element in the persuasive work needed to formulate policy directives that capitalize on community collaboration and coordination of social networks (Bass & Avolio, 1994). Together these elements are critical to the creation of effective service delivery mechanisms before, during, and after a disaster.

The Role of Leadership

March and Simon (1958) note that communities are social systems and as such rely on the contributions that individuals and organizations provide to the community. These contributions ensure the community's well-being through improving the quality of life as well as through management of risks. For example, well-developed organizations have emergency-response plans that coordinate resources with the community as well as with individuals who may provide financial, psychological, or intellectual resources that are easily accessible when disaster strikes.

Communities that have strong social cohesion as evidenced in their culture and social networks are better prepared to effectively respond to the aftermath of disasters. Thus, awareness of the possibility of a disaster in a community can vary depending on an individual's acquired knowledge and responsibility within the community. Typically residents have limited knowledge about potential disasters unless they are directly affected by them. Local awareness of the potential for a disaster may also be influenced by the predominant religion or culture, which may ascribe natural events such as a flood or hurricane to "the mighty will of God."

Consequently, awareness of the risk of disaster is an important aspect when considering the type and scope of leadership needed by those in positions of authority. The explicit recognition and acceptance of the legitimate power to participate (Pfeffer & Salancik, 1978), inform, and influence the processes that shore up a community's welfare is key to a leader's effectiveness. Kotter (1996) distinguishes the type of leadership needed during times of stability from what is needed during a crisis. A basic difference is that during a crisis the ability of a leader to convey a sense of urgency that is rooted in the cultural norms and behaviors of a region is crucial to the success of any relief effort.

A second key difference is that of coalition building (Kotter, 1996). During times of stability the need for private-sector agencies and government entities to work closely together is less evident. In sharp contrast, a disaster requires leaders to access networks of information and resources; they need to be inclusive and build coalitions that approach

disaster relief efforts creatively and comprehensively. Enactment of the leadership role (Burns, 1978) focuses on the ability to understand the actions of the players in an emergency situation. Enactment in this sense refers not only to what gets done but also to the manipulation, framing, and interpretation of events by those involved in relation to what was actually done (Weick, 1995). Creativity and innovation stem not only from the overall strategy that is in place but also from those who are implementing the strategy (Amabile, Schatzel, Moneta, & Kramer, 2004).

In general, leadership stresses the importance of *sense making* at different levels, that is, it fosters the ability of people to connect with others for both emotional stability and a sense of security (Goleman, Boyatzis, & McKee, 2002). During times of great instability, such as those created by a disaster, leaders need to make connections and build relationships with agencies and individuals outside their traditional networks of support. Through the expansion of their social networks they are able to access resources and expertise to successfully lead a community's effort at responding to the unexpected demands of a disaster. Leaders must be able to create coalitions that are broad enough to bring diverse groups together in order to effectively respond to the ever-changing conditions inherent to disaster relief activity (Kotter, 1996).

By necessity, leadership in disaster relief and recovery implies the ability to implement a response plan during a turbulent time. In the case of a tsunami, hurricane, or earthquake, the infrastructure of the community may be seriously damaged. While traditional community leaders can provide necessities essential for development, the challenges of implementing an action plan that is useful and immediately relevant in response to the urgent need of residents often overwhelm those who depend on consistency and stability.

Public administrators, elected officials, and different sectors of the community such as business, volunteer organizations, and religious organizations have to establish a process that allows them to grapple with uncertain conditions in order to ensure that the community is ready for an emergency. Key to the success of this effort is identifying essential information under extreme conditions such as the severity of the disaster, the number of jurisdictions involved, and access to resources (Comfort et al., 2004). Sometimes this is difficult because many elements of the community may want to focus only on the immediate and consider the idea of planning for the unexpected a waste of time and resources. Kotter (1987) notes that being proactive in identifying core values and generating goals that can be agreed upon by all parties is an important aspect of establishing an adaptive culture. This is especially true in an environment that concentrates on explicit and

implicit contractual relationships between the different constituencies making up a community (Bass, 1998).

Moreover, acting proactively harnesses the creative energy produced by the mix of government and community participants (Komada, 2006). To paraphrase Block (1993), the idea is to establish stewardship as a governance strategy (p. 22). Stewardship places the focus on the needs of the community at large rather than on who is in charge. Competition by leaders for control comes at the expense of identifying and gauging the constraints inherent when planning for eventual and potential disasters (Denis, Langley, & Pineault, 2000).

According to Collins (2001) effective leaders promote success by reinforcing the core values of a group, organization, or community and then using these to guide, not dictate, decisions (p. 198). In order to be effective, leaders must have a plan that is consistent with and supports the values and beliefs of community members. Thus the basis of success is collaboration, people working together. The perspective is a simple one: undertaking deliberations with stakeholders and including different views and concerns of people results in collective decision making.

Disaster relief and management, particularly when they involve international aid organizations, as was the case in the 2004 tsunami in Southeast Asia, constitute a multifaceted process, with many players and with differing and sometimes competing goals (Natsios, 1995; Telford & Cosgrove, 2007). The issue is one of learning. At one level, there is the learning on the part of individual community members of impending disasters and contingency plans to provide relief and recovery efforts. At another level, there is the learning that comes with planning for, identifying, and allocating needed resources to respond to a disaster. This last, though, is juxtaposed with the political learning that must occur regarding priorities and the costs associated with them, particularly when there is a conflict between policy and regulatory compliance mechanisms that may obscure priorities (Padró, 2006).

Conversations with community leaders in South Asia suggest that leaders must be able to articulate a vision for future disaster management and risk-aversion planning in three significant areas: (1) prioritizing needs, (2) educating residents, and (3) training first responders. They must be able to identify and articulate the needs and priorities of community residents in each of these activities. These can then be used to formulate an integrated plan of action that can then be communicated to residents through training and education.

A community that has engaged in emergency planning through the completion of a field survey identifying available resources prior to the onset of a disaster is in a better position to respond to its aftermath than one that has not engaged in such planning. Through planning, a community can identify how it will maintain basic operations for water

and sewage should power sources be interrupted or destroyed. As part of the planning activity indigenous knowledge inherited by people about early warning processes and escape routes can also be used. Moreover, the perceptions of residents about gender requirements and norms of interaction could be incorporated in the plan. Partnerships can also be formed in the planning stage between governmental agencies, volunteer organizations, and the private sector, but they should be ongoing to ensure access to the resources from these partners when disaster occurs.

By educating people about disasters, residents will have confidence that their community is prepared. In the context of this education effort, the chain of command should be clearly articulated in order to avoid confusion in a disaster. In addition, residents should be assured that disaster relief efforts are comprehensive and will address both the short- and long-term effects of a disaster. These include provision of essential necessities for the immediate needs of survivors as well as the resources needed to address prevention or mitigation of the effects of future disasters. It is important for community leaders to work closely with residents and provide feedback to government decision makers about community needs and what is and is not consistent with community norms and values.

Likewise, training emergency relief workers who are expected to be the first to arrive on the scene of a disaster is essential to the survival of residents and will further reinforce a sense of urgency needed for people to take ownership of mitigation, evacuation, and relief activities (Lichterman, 2000). Identification of who should be first to arrive on the scene must reflect the values and norms of residents who are affected and not the emergency relief organizations or the central government. Residents must be able to implicitly trust first responders and thus their selection must be grounded in religious, cultural, political, and economic considerations that have their roots in the cultural norms and values of the community.

By building broad coalitions, community leaders can have fruitful discussions with community members to identify suitable actions to ease the lives of residents after a disaster. This may involve directing specific resources to needy groups as well as maintaining contact with diverse stakeholders and agencies to acquire information. The ability of community leaders to listen and understand when to use their negotiation skills is essential to the maintenance of good rapport with community members who are in crisis and may be emotionally and physically distraught. Moreover, knowledge of the needs of various constituencies can occur only if the lines of communications are kept open (Comfort et al., 2004).

Importance of Accessing Resources

As part of the process of securing needed resources for a community after a disaster, community leaders must be able to quickly assess the damage caused by the disaster and obtain information on the availability of needed resources. This assessment should include not only the basic needs of food and shelter for residents but also the stability of infrastructure related to water, sanitation, and electricity. If the water supply has been compromised and/or the electrical power supply is destroyed, the risk of disease and death is higher and the resources needed to safeguard the population are greater. The results of this preliminary assessment should be reported to other communities, organizations, and government agencies as quickly as possible in order to access assistance. Leaders also need to look for support within the community and direct it to those most at risk, such as children and the elderly, in order to reduce the risk of infection and disease.

In rebuilding a community, community leaders will usually need to garner support from people outside the affected community. These include the broader public, the national government, local, national, and international relief organizations and other NGOs, as well as individual philanthropists to secure resources.

Leaders in Indonesia found that they also needed to secure resources within their community for rebuilding. This can be done in three ways. The first is to gain the participation of the people in the affected community through their contributions to rebuilding programs. This could be in the way of blankets and food as well as work efforts. Resources can be requested through collections from the community, governmental departments, and external donors and NGOs.

The second way is for leaders to actually collect funds from their own communities. Religious and cultural leaders can be recruited for this effort and are uniquely suited for this role as trusted individuals. Adequate funding must be allocated by a community to repair damaged infrastructure such bridges, roads, and buildings. These funds can also be used for rehabilitating religious buildings that can provide safe places for people to gather, to grieve for all they have lost, and to plan for how they will rebuild their lives.

Finally, community leaders are able to access needed resources through social capital if they have developed strong social networks that cross multiple sectors of influence such as government, business, religious, and cultural organizations. This social capital may manifest as timely and adequate communication impacting decision making regarding a disaster situation, an extremely important element in securing resources. When such communication has been established during the planning stage of disaster preparedness it is more likely to continue

through recovery despite the trauma and potential loss of life of key stakeholders. In fact, Lichterman (2000) found that by establishing and strengthening these networks during both the planning and training processes members of the community become resources that can be easily accessed when disaster strikes. Throughout the response to a disaster, it is important for leaders to maintain their contacts with the community as well as with provincial and central governments, the NGOs, and donor agencies to keep them abreast of the changing needs of the affected community.

Role of Leadership in Accessing Invisible Assets

Leaders can make effective use of the invisible assets of a community by accessing the traditional knowledge and experience of residents, such as coping mechanisms in emergency situations. Culture and attitudes on mutual help should also be taken into consideration. Providing awareness programs to the community will help to secure support since it will assist residents in understanding and accepting the chain of command needed for an effective response.

Until recently, most governments in South Asia and the Pacific, including Sri Lanka, had few relationship networks with community members to specifically address disasters. This limited governments' ability to access local social networks and their social capital and thus restricted opportunities to harness resources to assist affected communities. Instead, disasters were dealt with on a local level, and the government became involved only when needed, with little preplanning. For example, when an extreme event such as a tsunami occurred, volunteers were mobilized on an ad hoc basis. Because communities affected by disasters in Sri Lanka and Indonesia have a history of voluntary action, they are quite resilient at the personal and family levels. Rather than flee a disaster, they face it. Thus, the cohesion of the community is its greatest resource. However, due to the lack of widespread public knowledge about local mitigation activities, the government was unable to organize support from outside the affected community.

Realizing that civil society is an important source of invisible assets, the Government of Sri Lanka (GOSL) identified the great potential of volunteers in a possible future event. It also formally established a ministry specifically concerned with disaster management. Such efforts enable leaders to take advantage of high literacy rates and extended family systems and communicate with parallel community organizations to mitigate the consequences of a disaster. Residents in affected areas would work with the intervening people and teams to rebuild their lives and their communities.

The motivation to rebuild is another invisible asset that can be accessed in addressing the effects of a disaster. This attribute encourages creativity in the use of materials for building needed shelters and gives residents the courage and hope they need to make do without the comforts of life before the disaster. Thus, a future orientation, hopefulness, and the willingness to turn the disaster into an opportunity to rebuild are important hallmarks of invisible assets.

The Role of Leadership in Coordinating Local and International Organizations

While members of the government can sometimes assume leadership roles in a disaster, more often than not their role is one of support to local leaders. However, loss of credibility can destroy the possibility of any positive role. For example, the coordination activity of the GOSL during the 2004 tsunami was very poor. It lacked a clear policy or plan for coordinating local, national, or international organizations in relief operations. As a consequence, most of the international organizations acted on their own in coordinating their response with other NGOs.

International aid organizations often hire local residents to assist in the distribution of relief supplies. National and local government leaders can support these efforts and assist them in directing resources effectively. One such effort is the role the government plays in ensuring that the distribution of rations goes to those most in need. Otherwise residents who live or stay close to the main roads will get more support than those who are less able to stay near a road.

The government can thus occupy a central role in coordinating local and international organizations in relief operations. Several elements are critical to the success of this effort. The first is that such organizations must be culturally competent and willing to assist residents on their own terms. If an agency has a religious or political agenda, the success of its relief efforts will be compromised. Second, the network of coordination activities across the area must adhere to the laws of the local, regional, and central governments. In the case of the tsunami in South Asia, relief activities had to be sustained over an extended period because of the large scope of destruction and environmental degradation. Third, relief activities by aid organizations must be consistent with the central and local governments' development plans. For example, in Aceh, Indonesia, the central government provided a master plan to support rehabilitation and reconstruction in the affected area. Based on this master plan, the district government developed an action plan. Attention to the district government's action plan was an important consideration for aid organizations operating in the area.

It is important to note that disaster management can be compromised by the political environment in a country (Paul, 2003). Such was the case in Sri Lanka, where the government had the additional problem of limited access to the north of the country because of its control by rebel factions. Consequently, although the GOSL welcomed assistance from domestic and foreign NGOs, it was difficult for it to ensure the safety of aid workers in an environment complicated by war.

Leaders must also be able to coordinate the global network of support. For example, leaders in the GOSL were able to secure resources from development organizations such as the United Nations Development Program, World Bank, and Asian Development Bank after the tsunami for reconstruction projects. However, such work can be complicated by coordinating mechanisms that operate at diverse levels of jurisdiction. Thus, leaders in the central government must be able to form strong social networks with their counterparts at other levels of government as well as with leaders in cultural and religious organizations who can influence the availability of needed resources.

Governments must also be able to coordinate the relief efforts of a business community that is preoccupied with its own needs. By using its supply networks, the business community can assist with relief and recovery through donations or via financial support, for example assisting in the construction of new homes or providing new fishing boats. It may also be able to provide humanitarian aid and relief items to the community such as blankets, clothing, and food.

Although the business sector may reach out to affected communities, it is important to remember that this sector represents individual companies and not a group. Each business must take care of its own needs if it is to survive. Consequently, some business owners may move their headquarters to an area less affected by disasters; others may raise their prices on goods and services, increase premiums for housing and transportation insurance, or, if they do not have sufficient funds to rebuild, close their doors.

Although multinational corporations and large national corporations usually have insurance that covers the costs of repair from disasters, small businesses must usually turn to their creditors or to the government for assistance. For example, the toddy tapping industry along the Sri Lankan coast was particularly affected by the 2004 tsunami. Many of the trees used for tapping were destroyed, and processing equipment was washed out to sea or damaged. The industry sought assistance from the government for subsidies that could help revive businesses. In contrast, microenterprises that are by definition small self-employer businesses may not have the capital to rebuild nor access to government subsidies. Such operations may become unviable and close their doors.

Governments often form collaborations with NGOs in disaster management because they cannot provide all needed services directly to residents affected by a disaster. They therefore seek to form working partnerships with NGOs in order to access their considerable expertise and resources. Aid organizations such as the International Rescue Committee (IRC), the Red Cross, and Doctors Without Borders can move quickly into operation when disasters strike and deliver needed medical care and shelter to residents. In the case of the widespread destruction from the 2004 tsunami, governments recognized that NGOs could provide critically needed services more quickly, efficiently, and effectively if these aid organizations took the lead.

However, once the initial effort is under way government partnerships with NGOs in disaster management efforts may take several forms. One is that of technical assistance. Whereas local volunteer organizations may be familiar with the technical capabilities of the predisaster environment, an NGO such as the IRC may not be. As a result, an NGO may hire residents to assist in the recovery effort. Such was the case in Sri Lanka because the magnitude of the disaster was overwhelming for the government. NGOs, including Sarvodaya, a charity organization indigenous to Sri Lanka, Save the Children, and Christian Children's Fund, two organizations based in the United States that provide financial and advisory support to villages throughout Sri Lanka on a year-round basis, were able to assist the government by providing relief to many people in need.

Another type of partnerships is that of mobilization. After the tsunami struck, these NGOs were able to mobilize aid more quickly than the government because of bureaucratic slowdowns inherent in any government. In fact, the government needed the assistance of these organizations because of the overwhelming devastation and imminent risk of disease and death. Finally there is the potential partnership of communication. Aid workers in NGOs and voluntary organizations who are in the midst of the disaster can accurately identify changing environmental conditions and essential human needs. A partnership in this arena can provide critical information in a timely way that better directs the resources of governmental entities.

The relationship between a government and NGOs is not always easy, and thus leadership and the ability to find common ground in the delivery of needed services is crucial to success. Governments may form agreements with NGOs to ensure that aid is distributed equally among affected people. NGOs, particularly international aid organizations, may disagree with the priorities of the government or be critical of the information it provides. For example, an NGO may feel that the government is more concerned with its image in the press or its economic prospects than the real needs of the public. Given the tenuous nature

of the relationship of residents in South Asian countries and their governments identified by Co (2004), NGOs may not fully trust the information provided by the government and so rely instead on what is collected by local groups and foreign agencies working in the affected communities. Collaborating to successfully provide assistance requires that leaders build strong, mutual support and social networks that can in turn lead to improved coordination through the development of mutual trust and understanding.

Conclusion

Of primary concern in any disaster is the well-being of community members attempting to cope with loss, pain, and trauma. Residents may be in shock as they survey the destruction of everything they once knew and the death of many of their loved ones. These vulnerable residents need to be able to trust their community, religious, and cultural leaders to find and obtain the services and resources they will need to survive. This must be the concern of community leaders, governments, and NGOs, all of which have a role to play in disaster planning and recovery. When disaster strikes, community leaders need assistance with rescue, survival, and recovery for everyone, regardless of whether they are in areas that are remote, rural, coastal, or urban.

These leaders must also keep in mind the postdisaster needs of residents for assistance with their economic and long-term medical and mental health needs. In the case of the 2004 tsunami, residents of the affected areas lost everything, and nearly everyone became dependent, if only for a short time. In order to rebuild their lives and their communities, residents need the resources leaders can access through the diverse social networks they have.

Leaders can learn from communities that have handled disaster in the past, and people in these communities can play a key role in discussions on how best to manage a disaster. Leaders must build relationships across sectors of a community in order to create linkages with social networks outside their immediate circle. Residents with experience and knowledge of disaster recovery represent a powerful resource that can be used by leaders to better manage disasters.

Leadership in the public and private sectors is critical to effective disaster relief, management, and recovery. Given their positions in the community, leaders are observed by others and must therefore be able to model the behaviors they want to support and encourage. In order to effectively meet the many needs and often unanticipated scope of a disaster, leaders must have networks of people who have attributes they lack. For in the end, this will create opportunities for cross-fertilization

and thereby generate strong, dynamic solutions to the challenges presented by disasters.

References

Amabile, T. M., Schatzel, E. A., Moneta, G. B., & Kramer, S. J. (2004). Leader behaviors and the work environment for creativity: Perceived leader support. *Leadership Quarterly, 15,* 5–32.

Bass, B. M. (1998). *Transformational leadership: Industrial, military, and educational impact.* Mahwah, NJ: Lawrence Erlbaum Associates.

Bass, B. M., & Avolio, B. J. (1994). *Improving organizational effectiveness through transformational leadership.* Thousand Oaks, CA: Sage Publications.

Block, P. (1993). *Stewardship: Choosing service over self-interest.* San Francisco: Berrett-Koehler Publishers.

Burns, J. M. (1978). *Leadership.* New York: Harper & Row.

Cable News Network (2004, February 22). *Tsunami death toll.* Retrieved from http://articles.cnn.com/2004-12-28/world/tsunami.deaths_1_death-toll-tsunami-tamil-eelam?_s=PM:WORLD.

Chaskin, R. J., Brown, P., Venkatesh, S., & Vidal, A. (2001). *Building community capacity.* New York: Aldine de Gruyter.

Co, E. E. A. (2004). Civic service in East Asia and the Pacific. *Nonprofit and Voluntary Sector Quarterly, 33*(4), 127S–147S.

Collins, J. (2001) *Good to great.* New York: HarperCollins Publishing.

Comfort, L. K., Ko, K., & Zagorecki, A. (2004). Coordination in rapidly evolving disaster response systems: The role of information. *American Behavioral Scientist, 48*(3), 295–313.

Denis, J.-L., Langley, A., & Pineault, M. (2000). Becoming a leader in a complex organization. *Journal of Management Studies, 37*(8), 1063–1099.

Goleman, D., Boyatzis, R., & McKee, A. (2002). *Primal leadership: Realizing the power of emotional intelligence.* Boston: Harvard Business School Press.

Komada, M. (2006). Strategic community: Foundation of knowledge creation. *Research Technology Management, 49*(5), 49–58.

Kotter, J. P. (1987). Leadership: A constructive/developmental analysis. *Academy of Management Review, 12,* 648–657.

Kotter, J. P. (1996). *Leading change.* Boston: Harvard Business School Press.

Lichterman, J. D. (2000). A "community as resource" strategy for disaster response. *Public Health Reports, 115,* 262–265.

March, J. G., & Simon, H. A. (1958). *Organizations.* New York: John Wiley & Sons.

Natsios, A. S. (1995). NGOs and the UN system in complex humanitarian emergencies: Conflict or cooperation? *Third World Quarterly, 16*(3), 405–419.

Padró, F. F. (2006). Public policy as a dimension of institutional quality development in higher education. *Selected Papers of the 9th International QMOD Conference, 9 August–11 August 2006,* Liverpool, UK (11 pp.).

Paul, B. K. (2003). Relief assistance to 1998 flood victims: A comparison of the performance of the government and NGOs. *Geographical Journal, 169*(1), 75–89.

Pfeffer, J., & Salancik, G. R. (1978). *The external control of organizations.* New York: Harper & Row.

Sampson, R. J. (2008). What community supplies. In J. DeFilippis & S. Saegert (Eds.), *The community development reader* (pp. 163–174). New York: Routledge.

Telford, J., & Cosgrave, J. (2007). The international humanitarian system and the 2004 Indian Ocean earthquake and tsunamis. *Disaster, 31*(1), 1–28.

Weick, K. E. (1995). *Sensemaking in organizations.* Thousand Oaks, CA: Sage Publications.

Wollebaek, D., & Selle, P. (2002). Does participation in voluntary associations contribute to social capital? The impact of intensity, scope, and trust. *Nonprofit and Voluntary Sector Quarterly, 31*(1), 32–61.

Using Social Networks to Build Disaster-Resilient Communities

The Strategy of CODE ONE

Robin L. Ersing

Each year the Federal Emergency Management Agency (FEMA) processes disaster declarations filed by states stemming from weather-related events. The accumulated financial cost resulting from the destruction left behind has been estimated in the billions of dollars (FEMA, 2008). In 2010 alone, thirty-five states in addition to the U.S. Virgin Islands, Puerto Rico, and the District of Columbia filed disaster declarations as a result of severe storms, flooding, tornadoes, earthquakes, mud slides, tropical storms, and hurricanes (FEMA, 2011). Natural disasters of this magnitude exact a significant toll on local areas through not only the destruction of property but also the loss of life and the unraveling of the social fabric of the community. After Hurricane Katrina devastated the Gulf Coast region in August 2005, increased attention was directed toward building the capacity of vulnerable and distressed communities in an effort to reduce the magnitude of future losses and promote opportunities for more resilient recovery. As a result, interest has shifted to assessing local assets such as social networks and the capacity of area residents as untapped resources for mitigation strategies in readiness, response, and recovery. Such an emphasis is believed to chart a path to the development of disaster-resilient communities.

This chapter presents a community development approach to identify individual-level and organizational resources necessary to better

prepare and respond to critical-incident events. The concept of Community Oriented Disaster Education to Organize Neighborhoods in an Emergency (CODE ONE) is presented. This strategy is modeled after community action programs such as Neighborhood Crime Watch, established in neighborhoods nationwide. CODE ONE incorporates concepts from asset-based community development as integral elements in reducing hazard vulnerability. The central goal is to harness the resources and capital generated through social networks and ties that exist among community stakeholders in order to raise awareness and educate residents on disaster preparedness.

Hazards and Vulnerability

Preceding any disaster is a hazard, which emanates from some natural, human, or technological source and poses a potential *threat of harm* to the social, economic, or physical means of a region and its people (Pine, 2009). Localities experience a disaster when hazardous conditions exceed the community's ability to protect life, minimize loss of property, and keep intact the functioning of social, economic, and political systems (Paton, 2006). As discussed throughout this book, it is clear that not all hazards lead to disasters; however, all disasters are necessarily rooted in some type of hazardous state that has come to fruition. Factors such as time of onset, duration, intensity, and adverse impact on the population help determine whether a hazardous event transforms into a disaster (Rosenfeld, Caye, Ayalon, & Lahad, 2005). Simply put, a disaster of any magnitude is contingent upon the ability of a hazard to overwhelm the capacity of a community to adequately respond (FEMA, 1997).

Original thinking around natural hazards viewed these extreme events as external physical forces that leave a path of loss and destruction across a locality. This is typically accompanied by a breakdown in the social and economic systems of an area that overwhelms the capacity of the community to cope, thereby leaving people in a passive state of victimization (Tobin & Montz, 1997). More recently, however, a perspective has emerged that views a hazard through the lens of interaction with social and human forces, influencing the potential risk for disaster and the level of capacity for coping (Cutter, Boruff, & Shirley, 2003). This contemporary paradigm emphasizes the assessment of vulnerability, along with features of the particular hazard, to determine the threat of risk for people within a defined geographic setting. Wisner, Blaikie, Cannon, and Davis (2004) define vulnerability as "the characteristics of a person or group and their situation that influence their capacity to anticipate, cope with, resist and recover from the impact of a natural hazard" (p. 11). The concept of vulnerability in this approach

shifts attention to the role resources and assets play in buffering people, processes, and places when confronted with exposure to a natural hazard. More specifically, the assessment of vulnerability informs a community as to its potential for susceptibility to disaster risk and the degree of resilience to an extreme hazard (Pine, 2009, p. 10).

Assessing Vulnerability

Three common dimensions of disaster vulnerability include economic, geographic, and social characteristics (Mileti, 1999; Wisner et al., 2004). A vulnerability assessment is useful in examining indicators and identifying conditions that are likely to increase the level of disaster risk for a community. This process helps to clarify the interrelationship between human behavior and conditions of place and their potential to exacerbate or diminish the impact of a natural hazard.

Economic vulnerability refers to conditions of the local, regional, and national economies that influence livelihoods and the ability to overcome disruptions to the production and distribution of goods and services (Jones & Chang, 1995). Indicators of economic vulnerability can include impacts on employee wages, the physical condition and readiness of the labor force, and disruptions to the infrastructure (e.g., roads, transportation, and utilities).

Geographic vulnerability refers to the physical location of an area in relation to potential threats posed by a hazard. Demographics of the population of a place is another important element in assessing this type of vulnerability (Mileti, 1999). For example, the physical proximity of a locality to a shoreline determines whether a household is situated in a flood zone and might be threatened by the storm surge generated by a tropical storm or hurricane. Likewise, determining the distance to an evacuation route or emergency shelter can factor into the level of geographic vulnerability. The use of geographic information system applications in mapping disaster vulnerability helps to identify spatial areas with concentrated characteristics of vulnerability (e.g., increased rates of poverty, lack of access to private transportation, age or condition of housing stock, and populations of elderly or disabled individuals). Such information is useful to emergency managers in making decisions about where to locate points of distribution for water and other necessary supplies needed by communities.

Social vulnerability refers to characteristics and conditions that heighten the risk of impact from a natural hazard or disaster (Mileti, 1999; Pine, 2009). Age, race, and gender are often viewed as key sociodemographic variables in determining who is more likely to be threatened by exposure to an extreme event (Morrow, 1999). Children and the

elderly (La Greca, 2001; Tobin & Ollenburger, 1992) are thought to be particularly susceptible, as are women (Enarson, 1998). African-American and Latino populations are generally thought to experience greater hardship (Perry & Lindell, 1991). In addition, conditions such as poverty, low educational attainment, and health instability further conspire to compromise a person's defenses against the impact of a hazard (Pine, 2009; Wisner et al., 2004).

The role of social networks in assessing vulnerability to a natural hazard warrants particular attention. According to Dynes (2002), "social networks provide the channels whereby individuals develop a perception of risk and can be motivated to take some type of preventative action" (p. 18). In some cases having strong ties with individuals who share similar social and economic characteristics has been shown to provide increased sources of support and improved outcomes for mental and physical functioning, thereby reducing the risk of vulnerability (Haines, Beggs, & Hurlbert, 2002; Haines & Hurlbert, 1992). Likewise, social connections deemed to be weaker in nature but providing greater network diversity suggest increased access to harder-to-obtain resources (Granovetter, 1973; Unger & Powell, 1980). The term *optimal networks* has been used to represent a blending of these two perspectives (Hurlbert, Beggs & Haines, 2006). It suggests that individuals with access to social networks composed of relationships having strong ties with similar others (high density), as well as weaker social connections among a broader range of people (low density), are better able to access both supportive and more concrete resources to aid in disaster recovery.

Social networks can be viewed as a tangible form of social capital, resulting in the formation of trusting ties between people and links to support systems that can help to mitigate the impact of a disaster. Besides assessing vulnerability as a method for understanding the potential to cope with a natural hazard, risk-reduction models also assess capacities. This alternative approach emphasizes both internal and community-based strengths and assets that can be used to buffer the negative effects of a natural hazard (Tobin, 1999).

Community Resilience and Adaptive Capacity

Resiliency is often described as the ability to "bounce back," or to return to a state of functioning that was in place prior to exposure to a significant stressor such as a natural hazard. Paton (2006) reminds us that any attempt to return to a normal routine postdisaster is hindered by the changed physical and social environments attributed to the

impact of the hazard event. Therefore, it is often necessary for individuals to rely upon personal protective factors that manifest as coping skills in the recovery process. An example would be the reliance on social ties with family, friends, and neighbors in order to connect survivors to systems of mutual support.

Mayunga (2007) defines community disaster resilience as "the capacity or ability of a community to anticipate, prepare for, respond to, and recover quickly from impacts of disaster. This means that it is not only the measure of how quickly the community can recover from the disaster impacts, but also the ability to learn, cope with or adapt to hazards" (p. 4). Paton (2006) advances the concept of community resilience by recognizing the need to adapt to an altered reality postdisaster. As such, he addresses four components of "adaptive capacity" (p. 9). First is the need of the community to supply resources necessary to ensure safety and the continuity of basic functions. Second is the use of competencies to mobilize and apply resources to solve problems and adjust to a new reality. Third is the need for a strategy or plan to capitalize on opportunities for growth presented by the changed environment. Fourth is ensuring the sustainability of competencies and resources over time to address ongoing changes in the community.

At the community level, social networking can play an integral part in the ability of the local area to return to a predisaster state of functioning. Local areas that promote a sense of community and belonging are more likely to experience adaptive capacity as members use their social ties to stay connected and avoid a sense of isolation or separation from others (Paton & Johnston, 2001). As Paton and Johnston (2001) point out, the ability to adapt and grow after exposure to a disaster is not something that simply happens by chance. Instead, it requires a proactive approach and an intentional commitment to develop both personal and social assets. Building adaptive capacity is an empowering strategy that actively engages the local community in the mitigation of a natural hazard. The application of such a strategy is discussed below using a framework guided by principles of community development.

CODE ONE: A Community Mitigation Strategy

Citizen engagement, particularly through the active participation of community members in the development of hazard preparedness planning and recovery efforts, has become a growing movement across the nation and is viewed as an essential component of building community resilience (Mason, 2006; Rosenfeld et al., 2005). Some of this may be

attributable to increased communication from emergency management emphasizing the importance of self-sufficiency during the first seventy-two hours after a hazard event. In some cases it may take first responders that amount of time to safely make their way through debris to reach an impacted area (O'Leary, 2004). In the interim, community members are faced with relying on one another to cope not only in the immediate aftermath of the disaster but also in the longer-term recovery of the overall area.

CODE ONE is modeled after community-action programs such as Neighborhood Crime Watch. Although studies on the effectiveness of Neighborhood Crime Watch efforts to reduce criminal activity have been mixed (Holloway, Bennett, & Farrington, 2008), certain features of these programs offer opportunities to build capacity. Arguably, locality development activities such as these rely upon the use of social capital to strengthen social ties among neighbors for a common purpose, to reduce vulnerability and empower community members. Through the development of social networks, residents build trust capital along with a sense of engagement to share responsibility for the quality of life in the community and to take action when change is needed. Another feature used in promoting local community action is borrowed from the concept of "target hardening." Community crime prevention efforts include methods to make it more difficult for criminal activity to occur. Often this comes in the form of conducting a home security assessment to improve lighting, landscaping, and locks. Together, strengthening ties with neighbors and assessing the local community for ways to protect it from the impact of a natural hazard contribute to the framework of CODE ONE.

The overarching goal of CODE ONE is to promote community readiness through the formation of strong social networks that can be activated as a way to build capacity, reduce social vulnerability, and mitigate the impact of a natural disaster. The CODE ONE framework integrates concepts found in asset-based community development, community disaster education, and collective efficacy. Each of these components provides perspectives relevant to the capacity to recognize, organize, and mobilize assets and resources in order to be adequately prepared to withstand or bounce back from the impact of a natural hazard. A common denominator among these approaches is the connection between people and place, which encourages a sense of community. Paton and Johnston (2001) assert that, "The more people who are involved in community activities that engender a sense of community, efficacy and problem solving, the greater will be their resilience to adversity" (p. 274).

CODE ONE Framework

The operational framework for CODE ONE is depicted in figure 7.1 and begins by highlighting two core components: taking stock of the community and taking action within the community. First, at the broadest level, taking stock emphasizes the central tenet of understanding both the opportunities and challenges present within a community and how those factors contribute to a unique set of circumstances that must be addressed through a tailored disaster preparedness plan. As a result, both asset-based community development and community disaster education are part of this component of the CODE ONE framework.

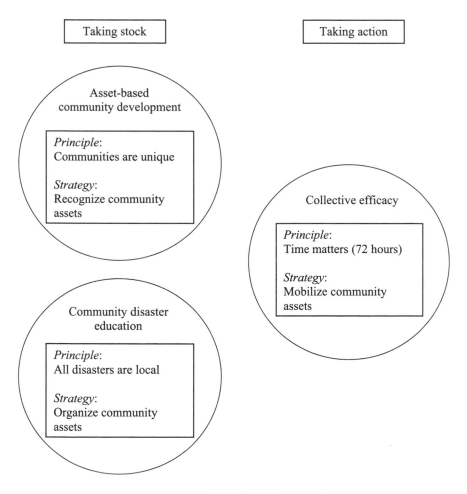

FIGURE 7.1 *CODE ONE framework*

Asset-based community development is a participatory approach that engages stakeholders in identifying (recognizing) the existing strengths and capacities of local residents, organizations, and institutions to empower the community and encourage sustainable change (Kretzmann & McKnight, 1993). Tools such as asset mapping and community resource assessments are often used to catalog indicators that suggest levels of social capital found in the locality. In terms of disaster resilience, social capital in the form of viable social networks and linkages with resources of local institutions raise the threshold for coping with a hazardous event.

National organizations like FEMA and the American Red Cross are well known for providing community disaster education to individuals and communities in an effort to prevent, prepare for, and respond to disasters. Often this knowledge is disseminated at the local level through trainings and outreach sessions organized by city or county emergency management groups, faith-based organizations, public service providers, and volunteer associations. Efforts to provide residents with information that will help them plan (organize) their response to the threat of a natural disaster contributes to enhancing coping capacities (Paton & Johnston, 2001). Raising social awareness can be thought of as an integral aspect of community resilience. Indeed, information that can save lives and protect property is a highly valued resource. The ability to communicate and educate through the distribution of information, particularly within socially vulnerable communities, provides a source of power that can influence decision making.

The second core part of the CODE ONE framework involves taking action to promote resilience. Taking action relies on applying the data or evidence gathered from the assessment of the local community to implement steps for adaptive coping during postdisaster recovery. Collective efficacy informs this component of CODE ONE by activating the levels of trust and cohesion found within social networks to provide a sense of safety, connectedness, and hope for a positive outcome.

Collective efficacy has been defined as "social cohesion among neighbors combined with their willingness to intervene on behalf of the common good" (Sampson, Raudenbush, & Earls, 1997, p. 919). This assessment fits with Paton and Johnston's (2001) notion that suggests successful disaster mitigation strategies are linked to levels of community involvement and cooperation. The concept of being called to action (mobilize) is particularly salient for groups of people who have been threatened with the impact of a natural disaster. Indeed, at both pre- and postdisaster we often see examples of neighbors, friends, and others spontaneously coming together to harden the geographic area against an impending hazard (e.g., boarding windows, sandbagging low-lying areas) or to begin the work of removing debris and searching

for survivors in the aftermath of an event. This form of social action response serves to mobilize assets and resources in order to begin the process of recovering and returning to a previous state of functioning as a community.

Principles and Applications of CODE ONE

Several principles and key strategies relevant to building disaster-resilient communities inform the application of CODE ONE within neighborhoods (see figure 7.1). In addition, table 7.1 provides a brief overview connecting each principle with a key strategy to build capacity and a mitigation focus to reduce vulnerability and promote community disaster resilience.

The first principle that guides the application of CODE ONE is the realization that every community has its own unique set of assets and resources. Indeed, CODE ONE is viewed as a strengths-based strategy that encourages the use of tools to recognize and catalog the distinct capacities that belong to each community. A variety of development tools are available to assess and inventory neighborhood assets and challenges. For example, a community capacity inventory (Kretzmann & McKnight, 1993) can be used by residents to collect information about the skills, talents, and abilities of community members, including the desire of individuals to share their skills by teaching others. Likewise, a community impact assessment (U.S. Department of Transportation, 1996) can be conducted to gather data on the social, economic,

TABLE 7.1
Linking capacity building and mitigation in CODE ONE

Conceptual element	Key capacity	Mitigation focus
Asset-based community development	*Recognize* local assets and resources and document for use in disaster planning	*Social capital* to develop and strengthen social networks and community ties
Community disaster education	*Organize* information and resources to develop disaster preparedness and recovery strategies	*Social awareness* to increase knowledge of hazards and educate others
Collective efficacy	*Mobilize* and activate resources in order to build capacity and reduce the risk of disaster	*Social action* to engage the community in cooperative assistance to problem-solve and advocate effectively

and environmental characteristics of a locality in order to create a community profile to evaluate potential impacts from a natural hazard. Finally, a number of tools are available to guide communities in developing and measuring quality-of-life indicators (Hart, 1999). Indicators of community well-being are often used to benchmark community goals and promote sustainability for positive long-term change. Less-formal tools to assess the unique features of a community include windshield surveys, in which data are collected using visual observation during a drive through a geographically defined area; and walkabouts, where people of all ages stroll the community observing and recording information about potential local resources. CODE ONE encourages the use of these data-driven methods to actively engage residents in building networks with decision makers to mutually determine the allocation of disaster assets as part of the preparedness plan for the local area.

The second guiding principle is the concept that all disasters are local. No matter the intensity, duration, or frequency of a hazardous event, decision making on how to prepare, respond, and recover begins within the impacted locality. Therefore, CODE ONE is designed to engage community members at the grassroots level and provide a conduit for communication with local emergency management leaders. According to Carafano and Weitz (2006), "The people closest to the problem are the ones best equipped to find the best solutions" (p. 2). Thus, residents should be provided the opportunity to offer input to the comprehensive emergency management plan as well as a voice in coordinating the assets of the neighborhood to provide the greatest benefit for reducing disaster risk. CODE ONE encourages local homeowner associations or other organized neighborhood groups to bridge communication with emergency managers and first responders, including fire, rescue, and police. Invitations to monthly or periodic community meetings help ensure an open flow of information and increase familiarity with the unique characteristics of a given area. One practical application is the partnership of residents sharing asset-assessment data with emergency planners so such data can be mapped and incorporated into response plans. This is particularly salient for raising awareness of any special needs community members may encounter during a disaster (e.g., use of oxygen, limited ability, cognitive impairments, etc.). Information collected by the community on the availability and accessibility of neighborhood assets and resources as part of preparedness planning is a capacity-building exercise designed to address vulnerabilities and lessen the negative effects of a hazard.

The third principle for applying CODE ONE is simply that time matters. The first seventy-two hours of a hazard event are considered critical to the search and rescue mission, as well as to sustaining survivors until professional responders arrive with supplies (O'Leary, 2004).

Disaster events such as category 3 hurricanes Katrina and Rita and category 4 hurricane Charley, which impacted communities in Louisiana, Texas, and Florida, respectively, clearly demonstrate the importance of having communities be prepared to self-sustain for as long as three days with little or no assistance from resources outside the landfall area. Applying the strategy of CODE ONE can assist communities in developing and deploying social networks that aid in immediate response efforts. Once again, organized communication among local residents and knowledge of special skills can further support these efforts in the immediate aftermath of a disaster. Social capital, manifested through collective action (e.g., cutting tree limbs, attaching blue tarps, preparing and sharing perishable food), becomes the glue that bonds neighbors and encourages continued pooling of resources and skills for the greater good of the neighborhood. CODE ONE also encourages collective action as a preparedness tactic to increase the number of community members who have received special volunteer training through programs such as the Community Emergency Response Team (CERT) and certification through the American Red Cross in first aid and CPR. Another practical application of CODE ONE is establishing a "know your role" community preparedness protocol that is adopted by households. For example, individuals with particular skills can agree to serve in a meaningful capacity to support the overall sufficiency of the neighborhood in the immediate aftermath of a hazard. Finding roles for youth to become engaged also adds to the resilience of the community.

Conclusion

A body of literature on social ties has suggested how people use their social connections to buffer negative perceptions of their neighborhoods, particularly fear of crime (Ross & Jang, 2000). Researchers interested in studying the vulnerability of people and communities in relation to exposure to natural hazards have also begun to focus on the role of social ties and connections both within and external to the community (Dynes, 2002; Riad, Norris, & Ruback, 1999; Wisner et al., 2004). Drawing from several constructs within that emerging literature, this chapter presented a community-based mitigation strategy known as CODE ONE to promote community resilience in coping with the impact of a natural disaster. CODE ONE is organized around a model of community development and social action. Strong emphasis is placed on the use of social networks and ties to build community capacity and reduce social vulnerability in an effort to buffer the impact of a natural disaster. An important outcome presented by CODE ONE is the realization of collective efficacy, developed through strengthening

social networks, to engage people as agents of change in promoting resilience through active participation in disaster-preparedness planning. CODE ONE counters more traditional top-down disaster risk reduction programs by advocating instead a grassroots approach that involves vulnerable communities in the development, implementation, and evaluation of hazard mitigation and preparedness activities.

References

Carafano, J. J., & Weitz, R. (2006, March). *Learning from disaster: The role of federalism and the importance of grassroots response* (Issue No. 1923). Washington, DC: The Heritage Foundation.

Cutter, S. L., Boruff, B. J., & Shirley, W. L. (2003). Social vulnerability to environmental hazards. *Social Sciences Quarterly, 84*, 242–261.

Dynes, R. (2002). The importance of social capital in disaster response. Preliminary Paper #327. University of Delaware Disaster Research Center.

Enarson, E. (1998). Through women's eyes: A gendered research agenda for disaster social science. *Disasters, 22*(2), 157–173.

Federal Emergency Management Agency (FEMA). (1997). *Multi-hazard identification and risk assessment: The cornerstone of the national mitigation strategy.* Retrieved April 20, 2010, from http://www.fema.gov/library/viewRecord .do?id=2214.

Federal Emergency Management Agency (FEMA). (2008). *Declared disasters.* Retrieved April 20, 2010, from http://www.fema.gov/news/disaster_totals_ annual.fema.

Federal Emergency Management Agency (FEMA). (2011). *Declared disasters.* Retrieved May 8, 2011, from http://www.fema.gov/news/disasters.fema? year=2010.

Granovetter, M. S. (1973). The strength of weak ties. *American Journal of Sociology, 78*(6), 1360–1380.

Haines, V., Beggs, J. J., & Hurlbert, J. S. (2002). Exploring structural contexts of the support process: Social networks, social statuses, social support, and psychological distress. *Advances in Medical Sociology, 8*, 271–294.

Haines, V., & Hurlbert, J. S. (1992). Network range and health. *Journal of Health and Social Behavior, 33*, 254–266.

Hart, M. (1999). *Guide to sustainable community indicators* (2nd ed.). West Hartford, CT: Sustainable Measures.

Holloway, K., Bennett, T., & Farrington, D. P. (2008). *Crime prevention research review no. 3: Does Neighborhood Watch reduce crime?* Washington, DC: U.S. Department of Justice, Office of Community Oriented Policing Services.

Hurlbert, J. S., Beggs, J. J., & Haines, V. A. (2006). Bridges over troubled waters: What are the optimal networks for Katrina's victims? *Understanding Katrina: Perspectives from the social sciences.* Retrieved April 20, 2010, from http://understandingkatrina.sscr.org.

Jones, B., & Chang, S. (1995). Economic aspects of urban vulnerability and disaster mitigation. In F. Cheng & M. Sheu (Eds.), *Urban disaster mitigation: The role of engineering and technology* (pp. 311–320). Oxford: Elsevier Science.

Kretzmann, J. P., & McKnight, J. L. (1993). *Building communities from the inside out: A path toward finding and mobilizing a community's assets*. Evanston, IL: Asset-Based Community Development Institute, Institute for Policy Research, Northwestern University.

La Greca, A. M. (2001). Children experiencing disasters: Prevention and intervention. In J. N. Hughes, A. M. La Greca, & J. C. Conoley (Eds.), *Handbook of psychological services for children and adolescents* (pp. 195–222). Oxford: Oxford University Press.

Mason, B. (Ed.). (2006, March). *Community disaster resilience: A summary of the March 20, 2006 Workshop of the Disasters Roundtable*. Washington, DC: National Research Council.

Mayunga, J. S. (2007, July). *Understanding and applying the concept of community disaster resilience: A capital-based approach*. Munich, Germany: Summer Academy for Social Vulnerability and Resilience Building.

Mileti, D. S. (1999). *Disasters by design: A reassessment of natural hazards in the United States*. Washington, DC: Joseph Henry Press.

Morrow, B. H. (1999). Identifying and mapping community vulnerability. *Disasters, 23*(1), 1–8.

O'Leary, M. (2004). *The first 72 hours: A community approach to disaster preparedness*. New York: iUniverse.

Paton, D. (2006). Disaster resilience: Building capacity to co-exist with natural hazards and their consequences. In D. Paton & D. Johnston (Eds.), *Disaster resilience: An integrated approach* (pp. 3–10). Springfield, IL: Thomas.

Paton, D., & Johnston, D. (2001). Disasters and communities: Vulnerability, resilience and preparedness. *Disaster Prevention and Management, 10*(4), 270–277.

Perry, R. W., & Lindell, M. K. (1991) The effects of ethnicity on evacuation decision-making. *International Journal of Mass Emergencies and Disasters, 9*(1), 47–68.

Pine, J. C. (2009). *Natural hazards analysis: Reducing the impact of disasters*. New York: CRC Press.

Riad, J. K., Norris, F. H., & Ruback, R. B. (1999). Predicting evacuation in two major disasters: Risk perception, social influence, and access to resources. *Journal of Applied Social Psychology, 29*(5), 918–934.

Rosenfeld, L. B., Caye, J. S., Ayalon, O., & Lahad, M. (2005). *When their world falls apart: Helping families and children manage the effects of disasters*. Washington, DC: NASW Press.

Ross, C. E., & Jang, S. J. (2000). Neighborhood disorder, fear, mistrust: The buffering role of social ties with neighbors. *American Journal of Community Psychology, 28*(4), 401–420.

Sampson, R. J., Raudenbush, S. W., & Earls, F. (1997). Neighborhoods and violent crime: A multilevel study of collective efficacy. *Science, 277*(5328), 918–924.

Tobin, G. A. (1999). Sustainability and community resilience: The holy grail of hazards planning. *Environmental Hazards, 1*, 13–26.

Tobin, G., & Montz, B. (1997). *Natural hazards*. New York: Guilford.

Tobin, G. A., & Ollenburger, J. C. (1992). *Natural hazards and the elderly* (QR53). Natural Hazards Research and Applications Information Center, University of Colorado, Boulder.

Unger, D. G., & Powell, D. R. (1980). Supporting families under stress: The role of social networks. *Family Relations, 29*(4), 566–574.

U.S. Department of Transportation. (1996). *Community impact assessment: A quick reference for transportation.* Washington, DC: Federal Highway Administration.

Wisner, B., Blaikie, P., Cannon, T., & Davis, I. (2004). *At risk: Natural hazards, people's vulnerability and disasters* (2nd ed.). New York: Routledge.

Contributors

Ruth W. Edwards, MBA, PhD, is senior partner at FlashStone Research & Consulting, LLC.

Margarethe Kusenbach, PhD, is associate professor, Department of Sociology, University of South Florida.

Susan Markus, MS, LPC, is a PhD student in educational leadership, University of Wyoming. She is deputy director of the Wyoming Health Council.

Golam M. Mathbor, PhD, is professor, School of Social Work, and associate dean, School of Humanities and Social Sciences, Monmouth University, New Jersey.

Dhrubodhi Mukherjee, MSW, PhD, is assistant professor, School of Social Work, Southern Illinois University, Carbondale.

Hussein H. Soliman, MSW, PhD, is professor and Alber Humanitarian Umm Al Qura Professor, School of Social Work, Southern Illinois University, Carbondale.

Carylanna Taylor, MS, is a doctoral candidate in applied anthropology at the University of South Florida.

Index

Note: Page numbers followed by "f" refer to figures. Page numbers followed by "t" refer to tables.

About the Editors

Robin L. Ersing, MSW, PhD, is associate professor in the University of South Florida School of Social Work. She has taught in the areas of macro social work practice, social welfare policy, and research. Current research focuses on disaster vulnerability among women, evacuation behavior and the role of social networks, and factors influencing community disaster resilience.

Kathleen A. Kost, MA, MSSW, PhD, is associate professor at the University of Buffalo School of Social Work. She has taught in the areas of social welfare policy, organizational behavior and management, community practice, and research methods. Current research focuses on models of organizational collaboration and their effects on resource-poor communities and agencies that serve low-income people, particularly in their capacity to respond to disasters.